POSTCARDS FROM MERION
by Nancy Clearwater Herman

This book is an homage to the Main Line, an unofficial historical and socio-cultural region of suburban Philadelphia, Pennsylvania, comprising a collection of towns built along the old Main Line of the Pennsylvania Railroad which ran northwest from downtown Philadelphia. Originally many people had homes in Philadelphia and country estates along the Main Line. Merion, the author's home, is the first stop on the line in Lower Merion Township. These are works from her blog, POSTCARDS FROM MERION, where she posts daily paintings from the area.

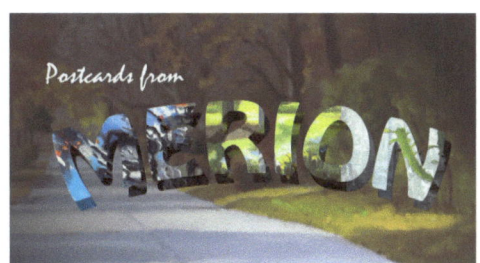

http://postcardsfromthemainline.blogspot.com/

BRYN MAWR IN THE RAIN (cover)

Rain creates a whole new image of life. There are 3 versions of reality in this painting. There is the solid version, the one created by the rain puddles on the street and pavement, and the one created by the windshield.
How much of our perception is distorted in just this way, as we look at the world through the prism of our prejudices, past experience and just plain ignorance.

"Where we love is home - home that our feet may leave but not our hearts."

Oliver Wendell Holmes

This book is devoted to some of the small paintings I've made in and around Merion, Pennsylvania, places that are a delight to me close to home.
These spots make up the character of this
little slice of the world. The Main Line is a beautiful place to live and I am grateful to have spent the last 40 years here.

Nancy Herman
http://postcardsfromthe mainline.blogspot.com/

Postcards from Merion

THE YELLOW WALL

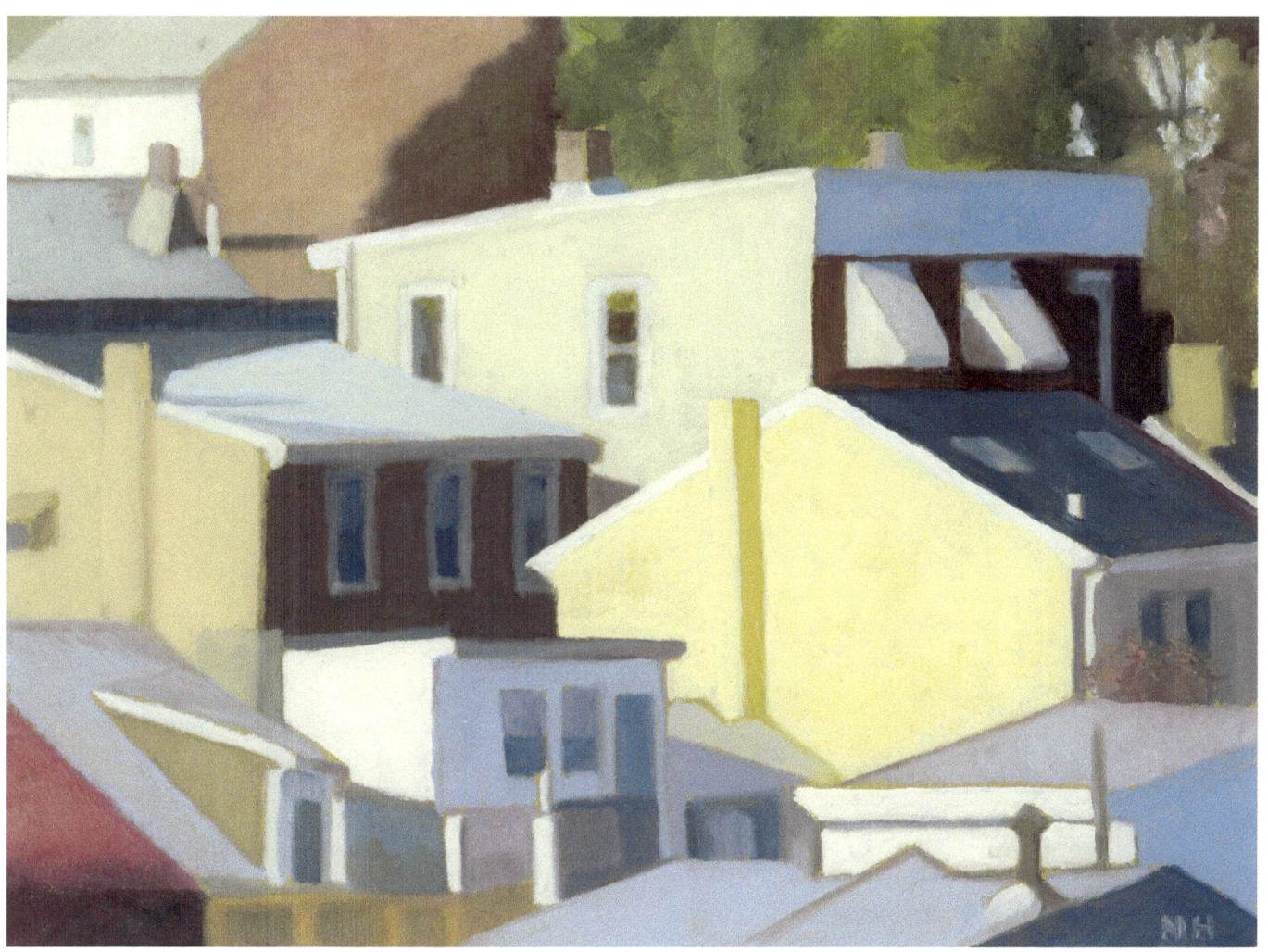

A view of Manyunk from the Cynwyd Heritage Trail

Postcards from Merion

THE BRYN MAWR FILM INSTITUTE

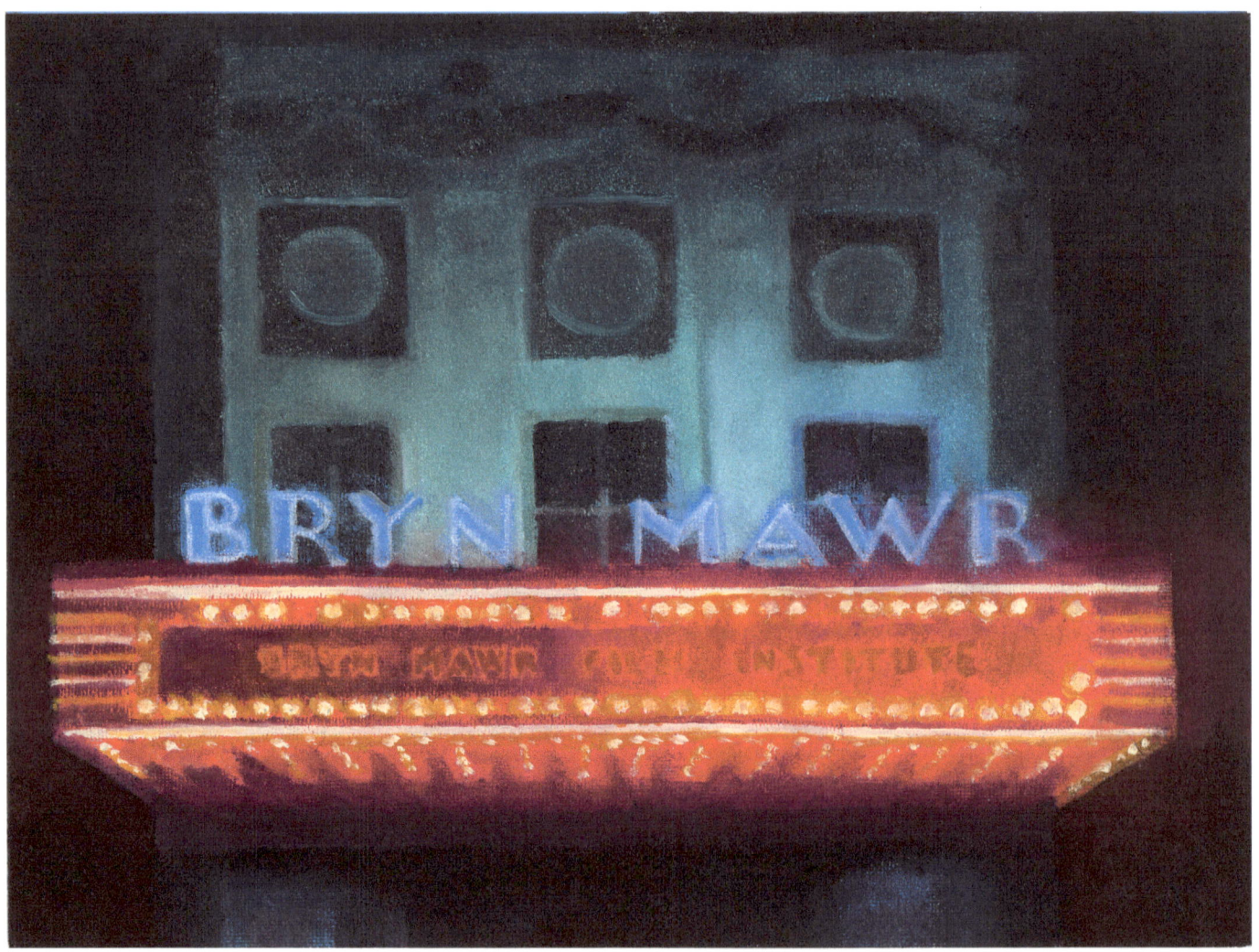

*Saved by the prodigious energies of Juliet Goodfriend,
who has lived up to her name by being a good friend to all
in this area by creating this wonderful cultural gathering place.*

Bryn Mawr

Postcards from Merion

FARMER'S MARKET

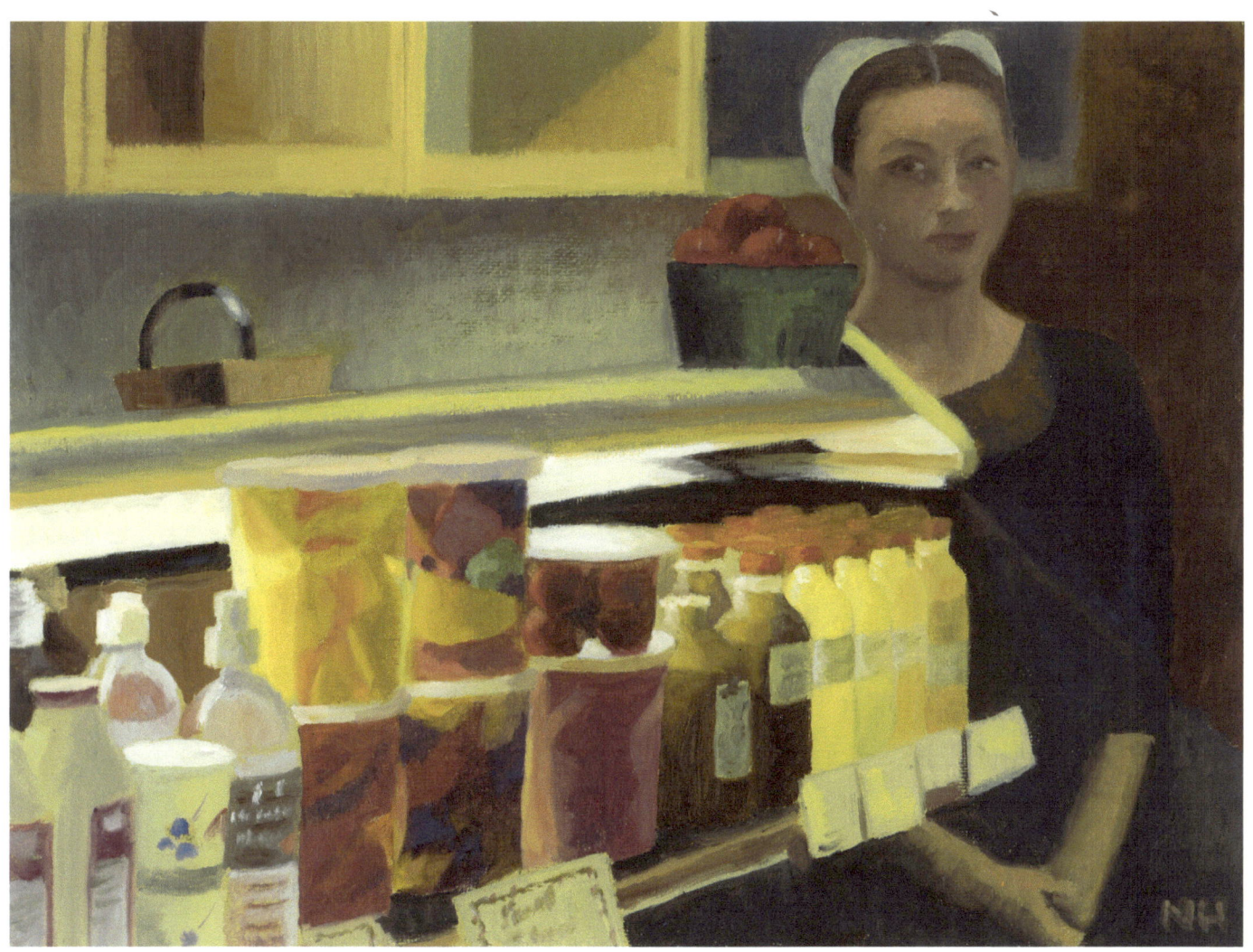

What does this young country woman think of her customers?
Ardmore

Postcards from Merion

EMPTY SHOP REFLECTIONS

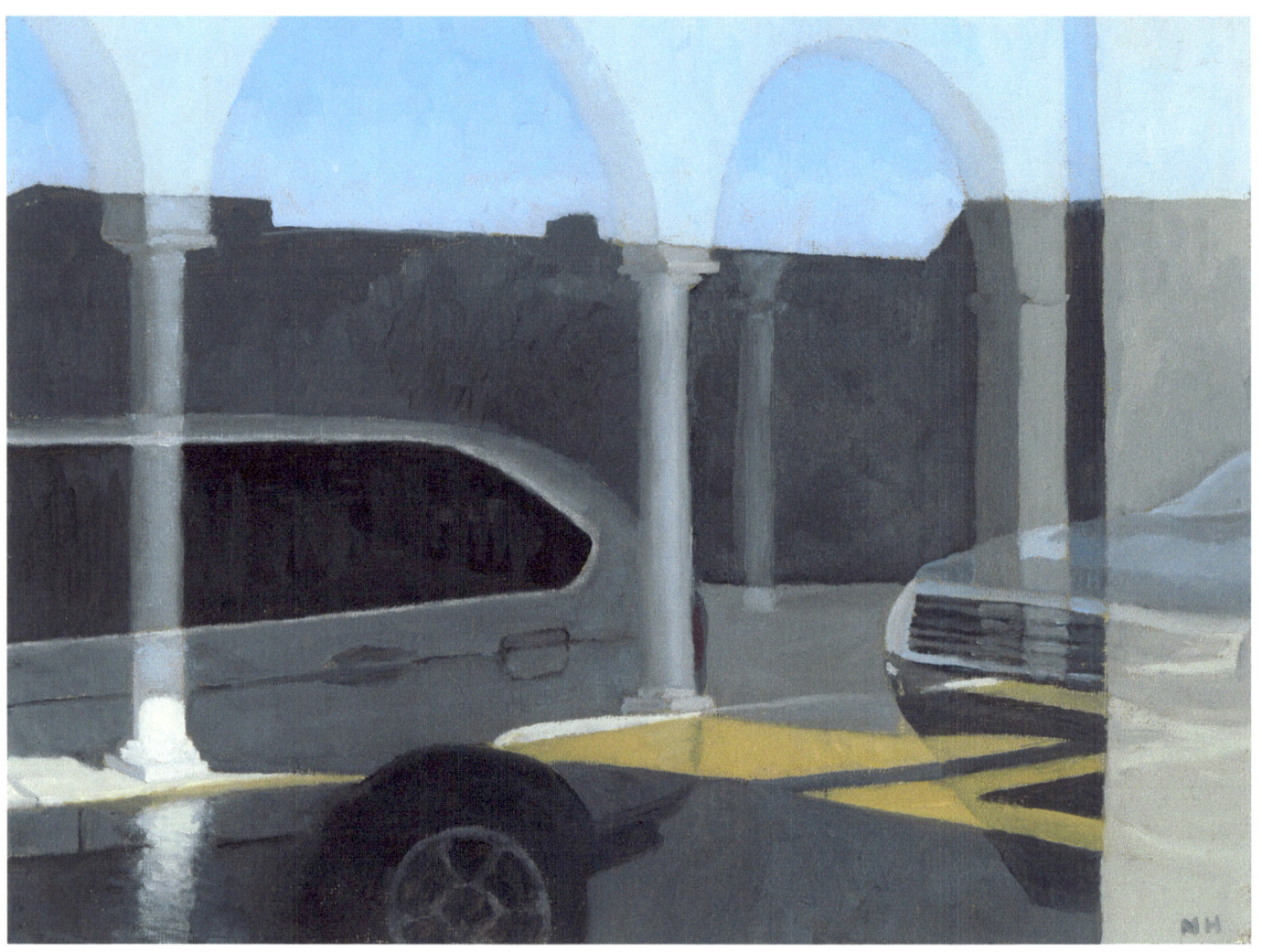

The interior of a closed store is a lonely place. Here the reflections of cars parked for thriving stores mix with the empty arches of this abandoned space in Suburban Square.
Ardmore

Postcards from Merion

DRIVING IN THE FOG

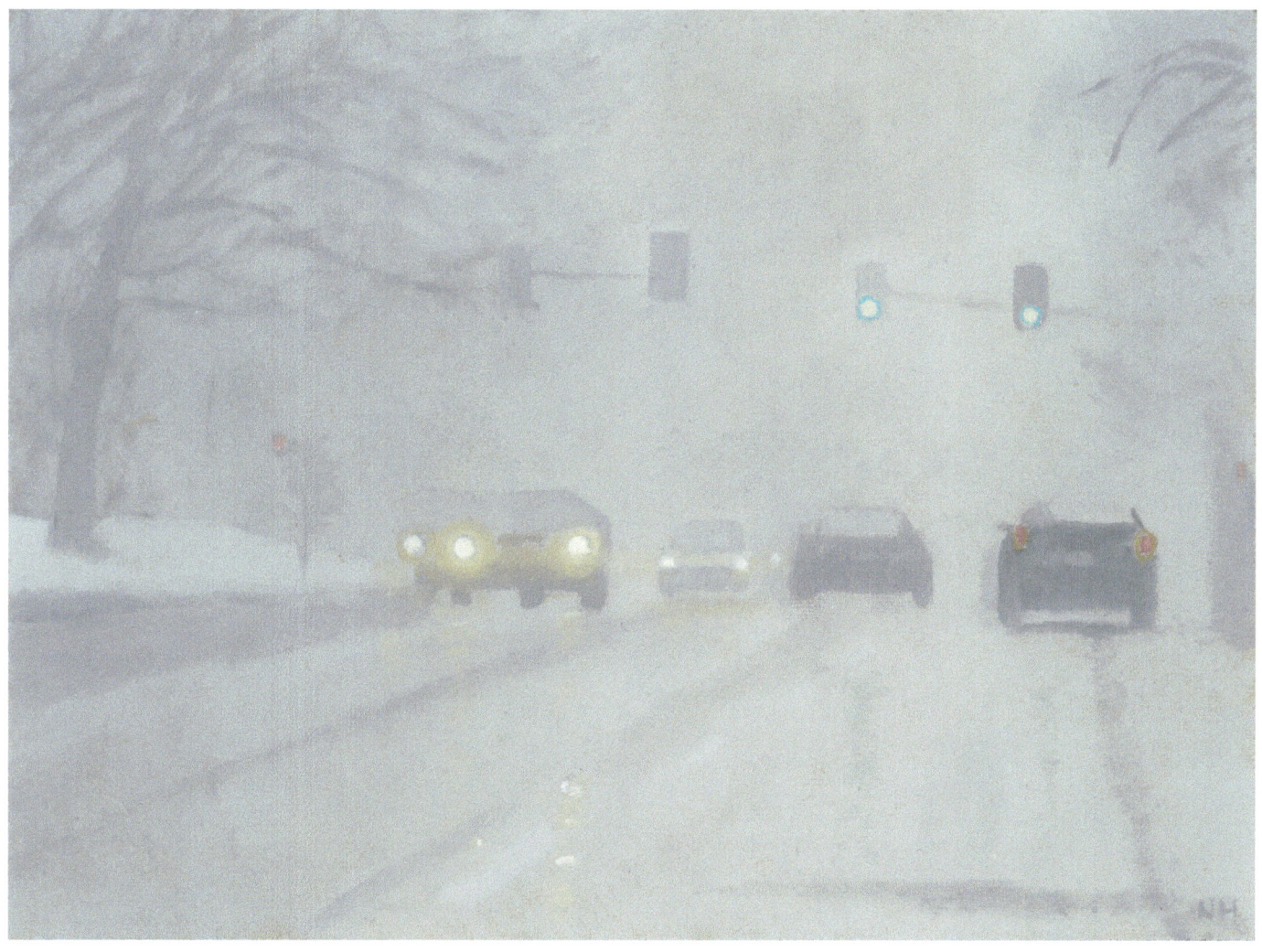

An ordinary drive takes on an air of mystery in the fog.
Ardmore

Postcards from Merion

ARDMORE TOPS

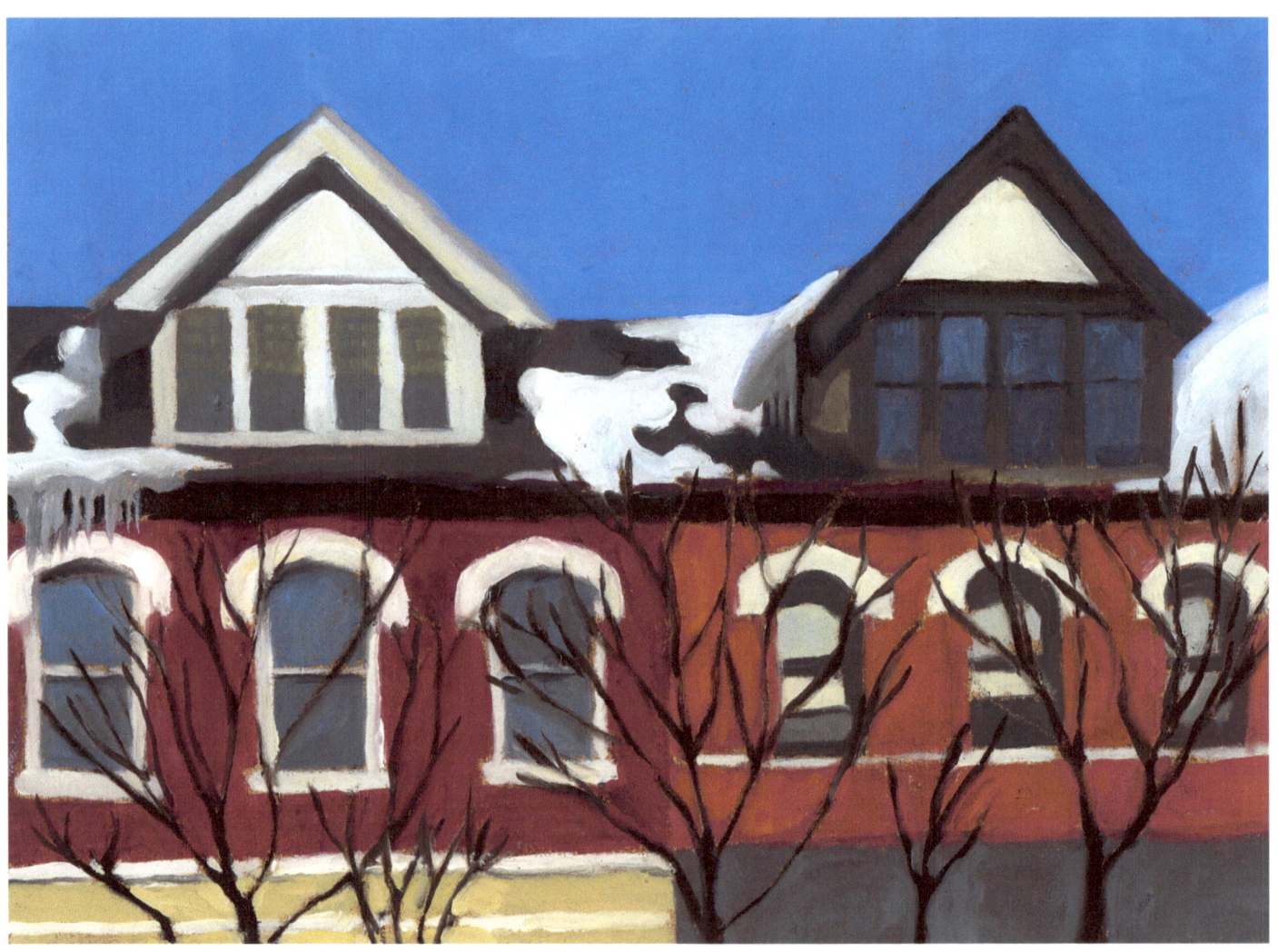

These cheery rooftops in Ardmore seem to be dancing with the snow.

Postcards from Merion

REAR VIEW

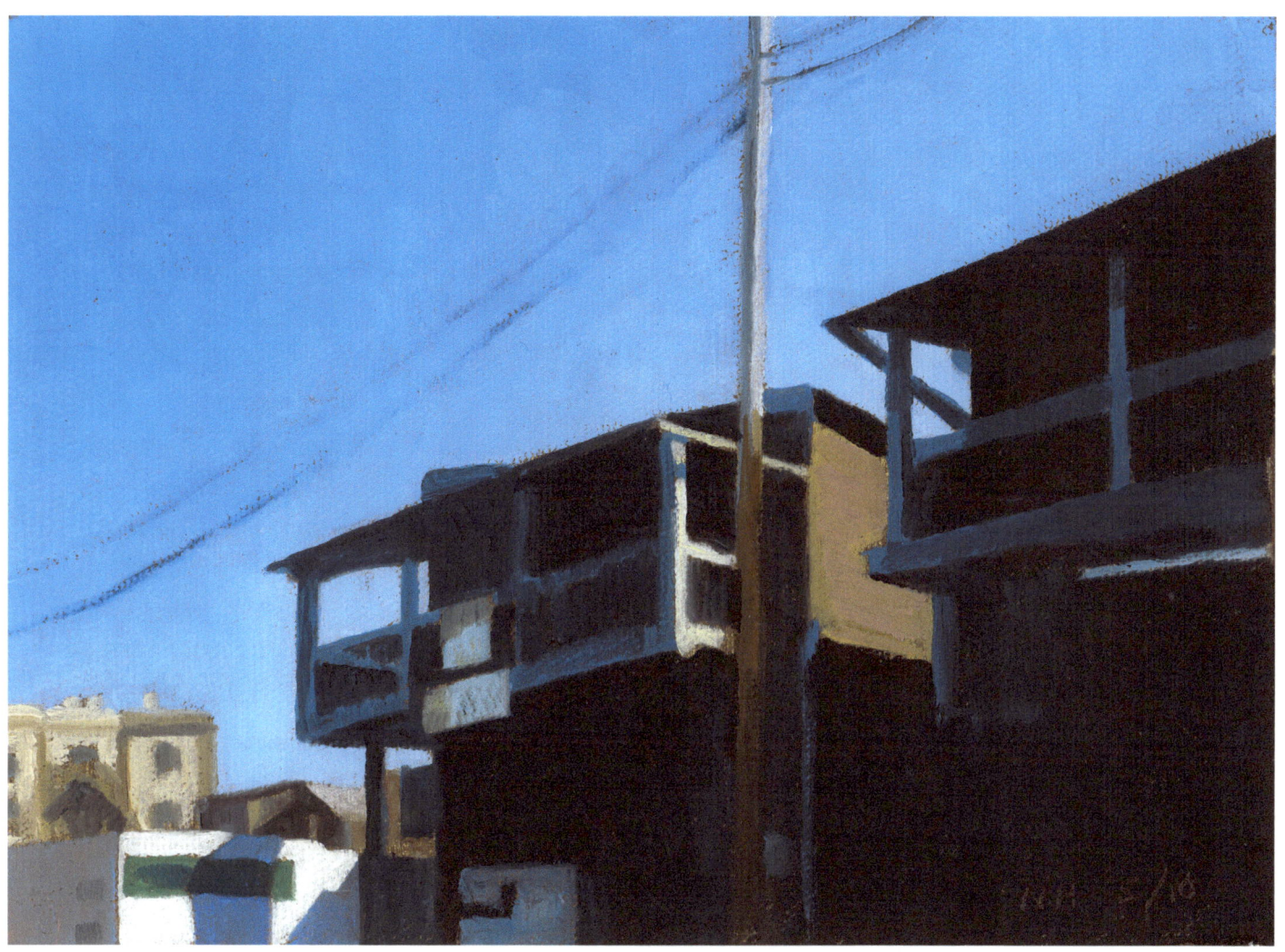

What goes on in the spaces above stores? Here are some interesting ones seen from the parking lot in Ardmore.

Postcards from Merion

MERION FRIENDS MEETING HOUSE

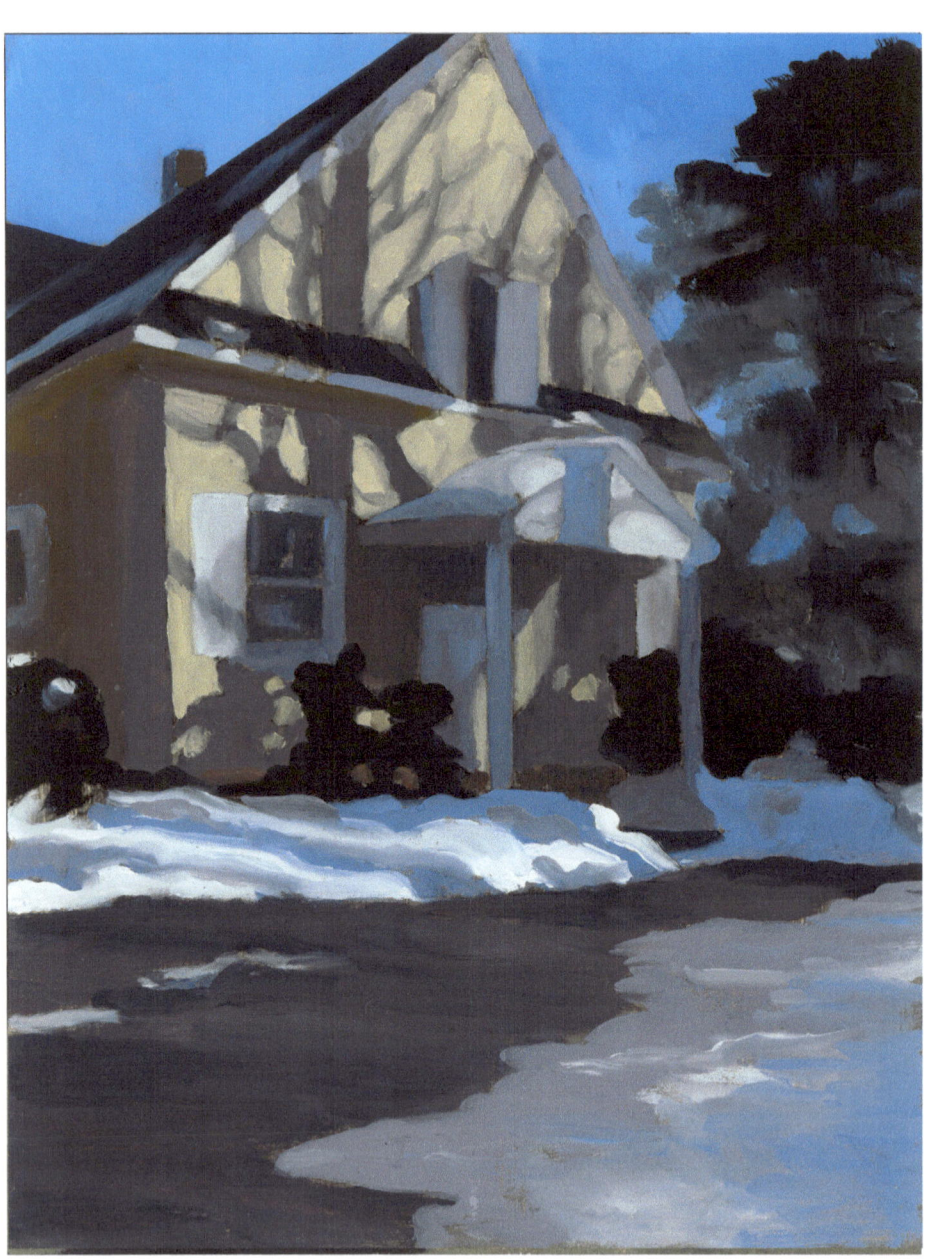

The Merion Friends Meeting House is one of the most serene and lovely places on the Main Line.

It is located on a very busy street and yet once you walk up the lane you are back to 1695 when it was originally constructed.

Postcards from Merion

STABLES AT MERION FRIENDS MEETING HOUSE

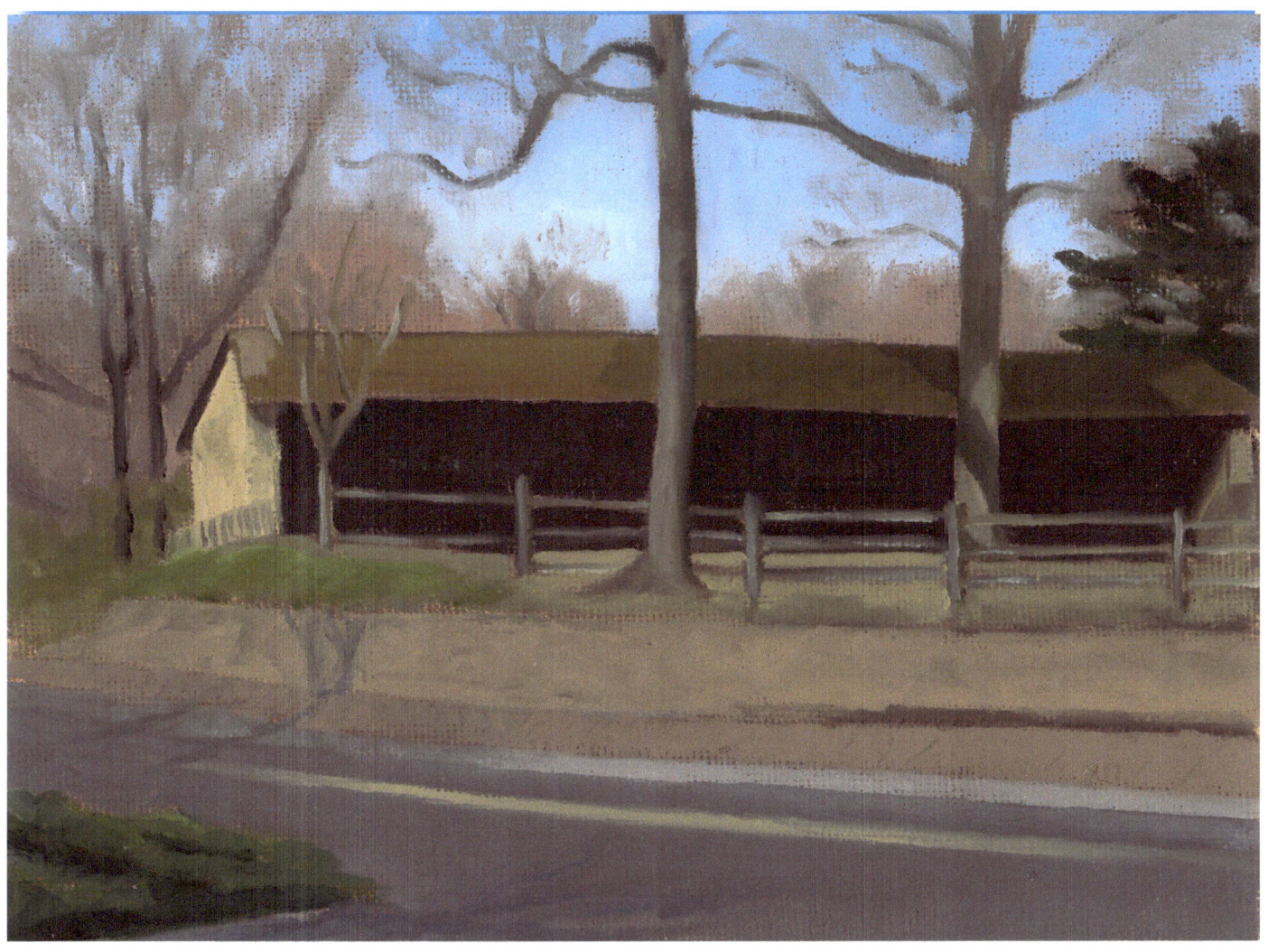

The beautiful old stables at the Meeting House feel like they are a part of nature.
Merion

Postcards from Merion

GENERAL WAYNE INN

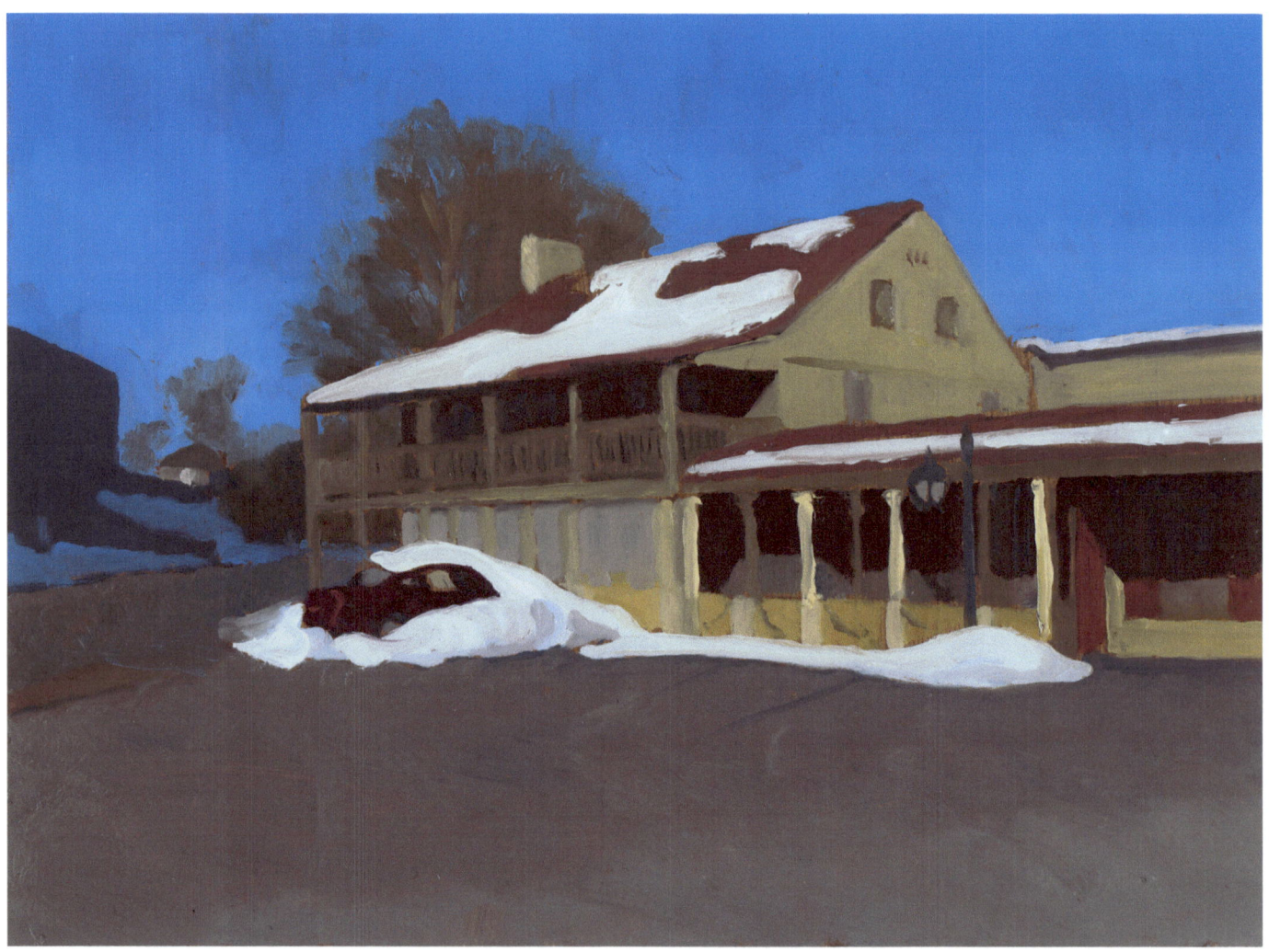

The General Wayne Inn, built in 1704, with a rich history of
ghosts and a real murder in recent years, sits calmly waiting
for whatever the 21st century has to offer.
Merion

Postcards from Merion

REFLECTIONS

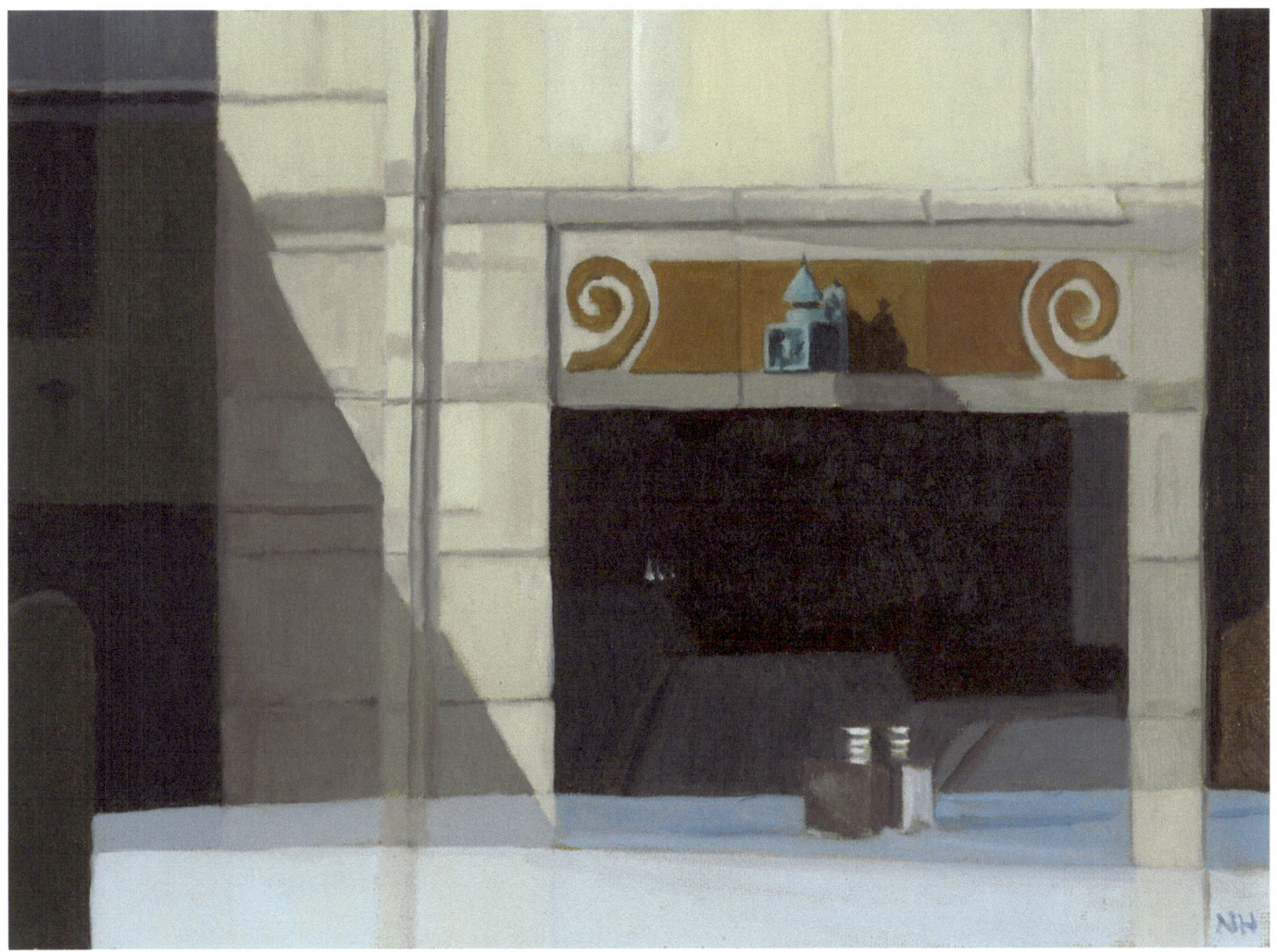

*Looking into one of the restaurants on Bala Avenue,
you can see part of the decorations on the old Art Deco Bala Theatre
reflected in the window.
Bala Cynwyd*

Postcards from Merion

SQUIRREL CROSSING

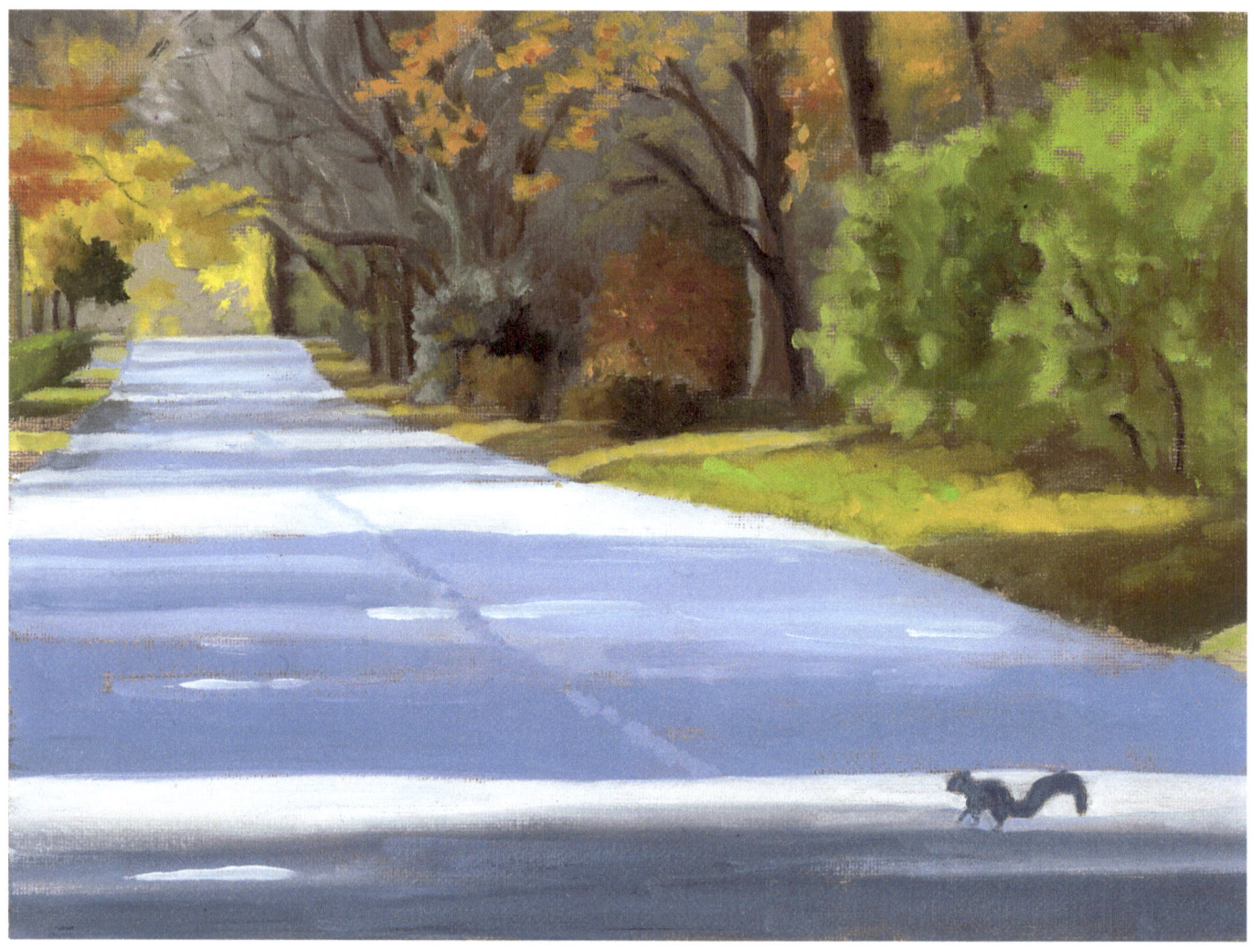

How do squirrels communicate the danger of crossing the street to their buddies, since those who don't make it have little to tell?
Merion

Postcards from Merion

CARRIAGE HOUSE

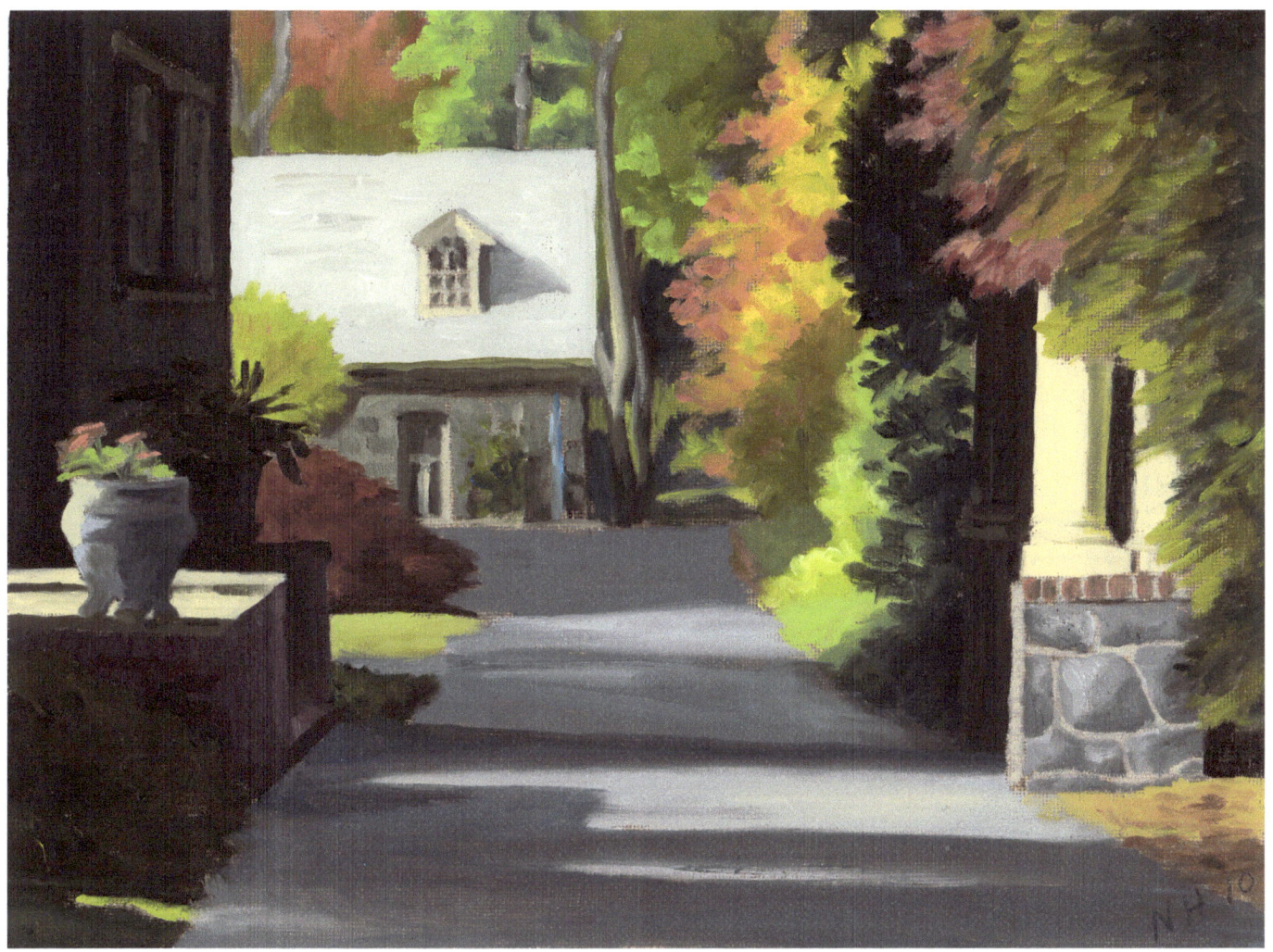

Lots of carriage houses in the Main Line but very few stables.
Where did the horses stay?
Merion

Postcards from Merion

RED WHEELBARROW

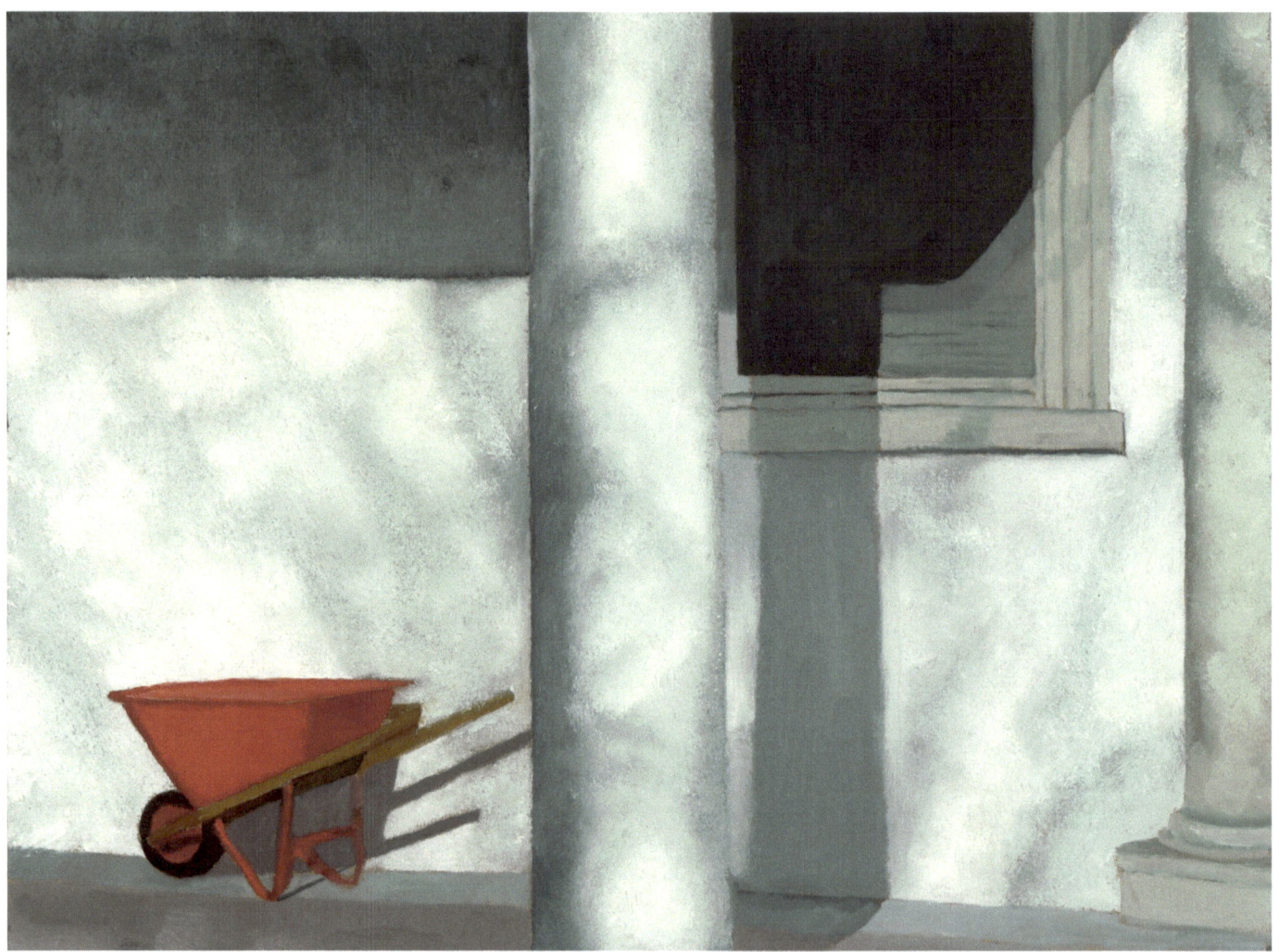

This little red wheelbarrow is waiting for the imagination of some child who will tote something around the yard in that semi dream that only childhood make-believe provides.
Bala Cynwyd

Postcards from Merion

LETTER ON THE BENCH

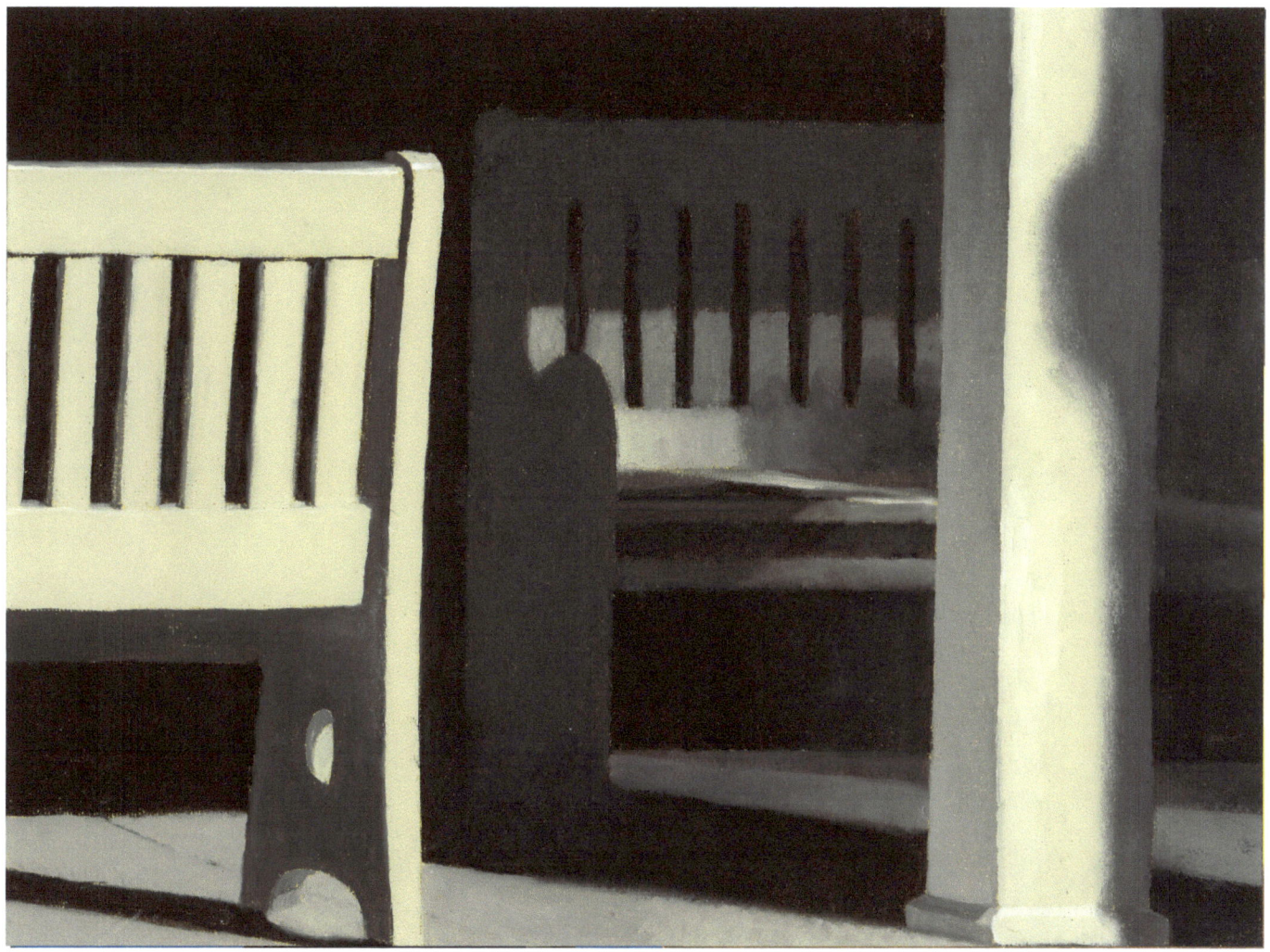

*These benches seem to be talking to each other in the late afternoon sun. Someone has left a letter on one of them.
Is that what they are discussing?
Bala Cynwyd*

Postcards from Merion

SUMMER MARKET

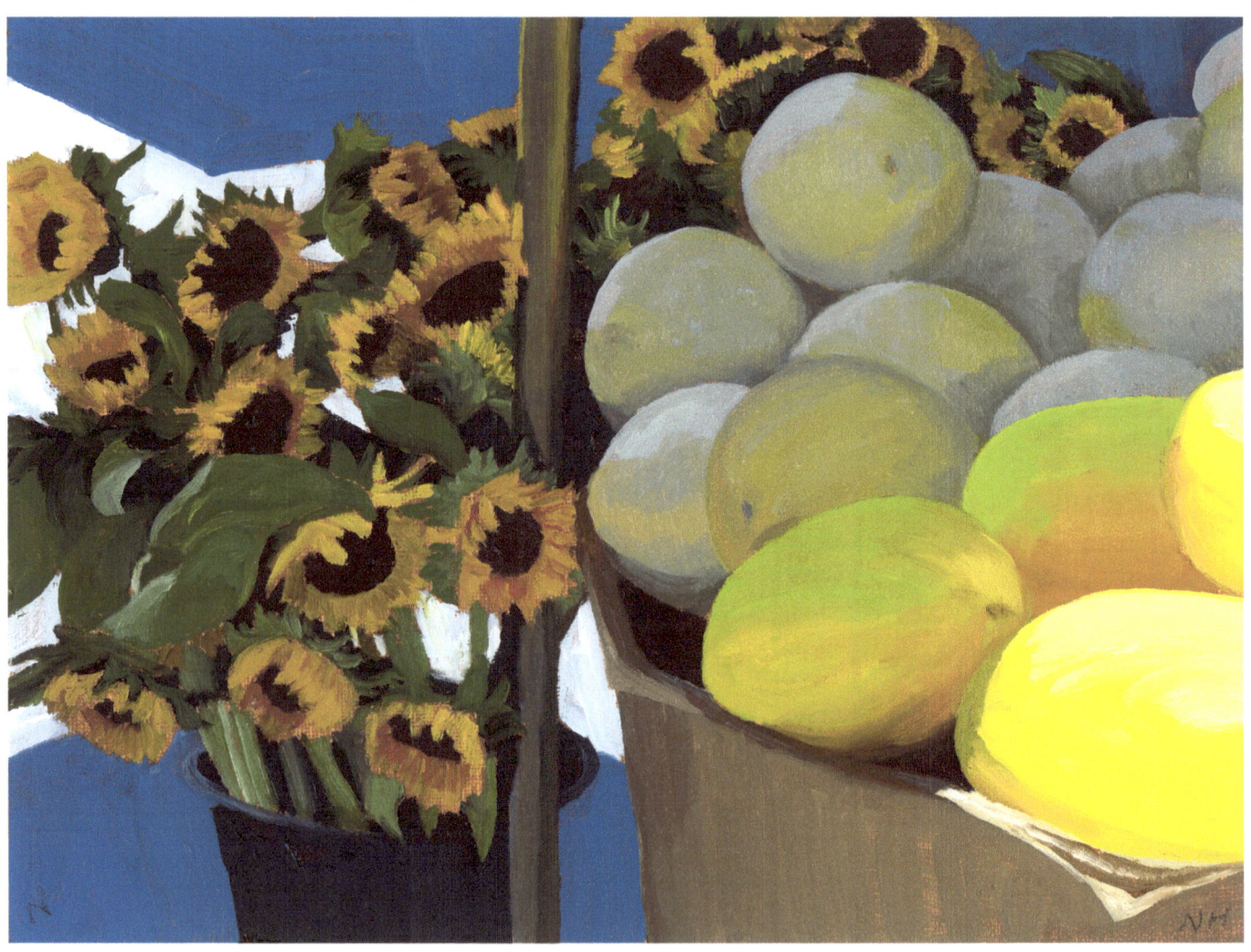

What a happy pairing of sunflowers and sunny melons.
Wynnewood

Postcards from Merion

SUMMER MARKET #2

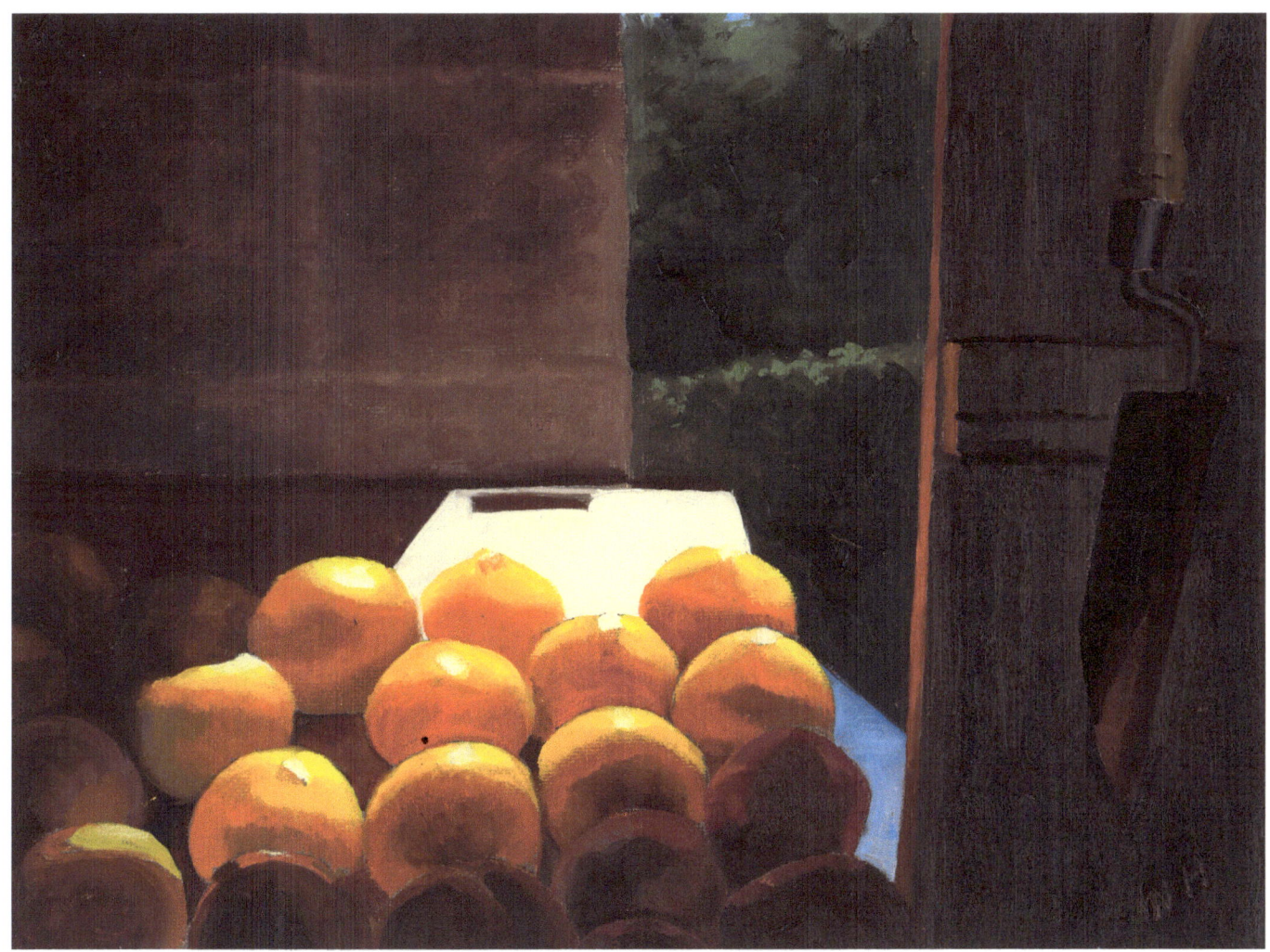

The orange color reflected on the door and even the shovel attracted me to this spot at the market in Wynnewood.

Postcards from Merion

LEAVING

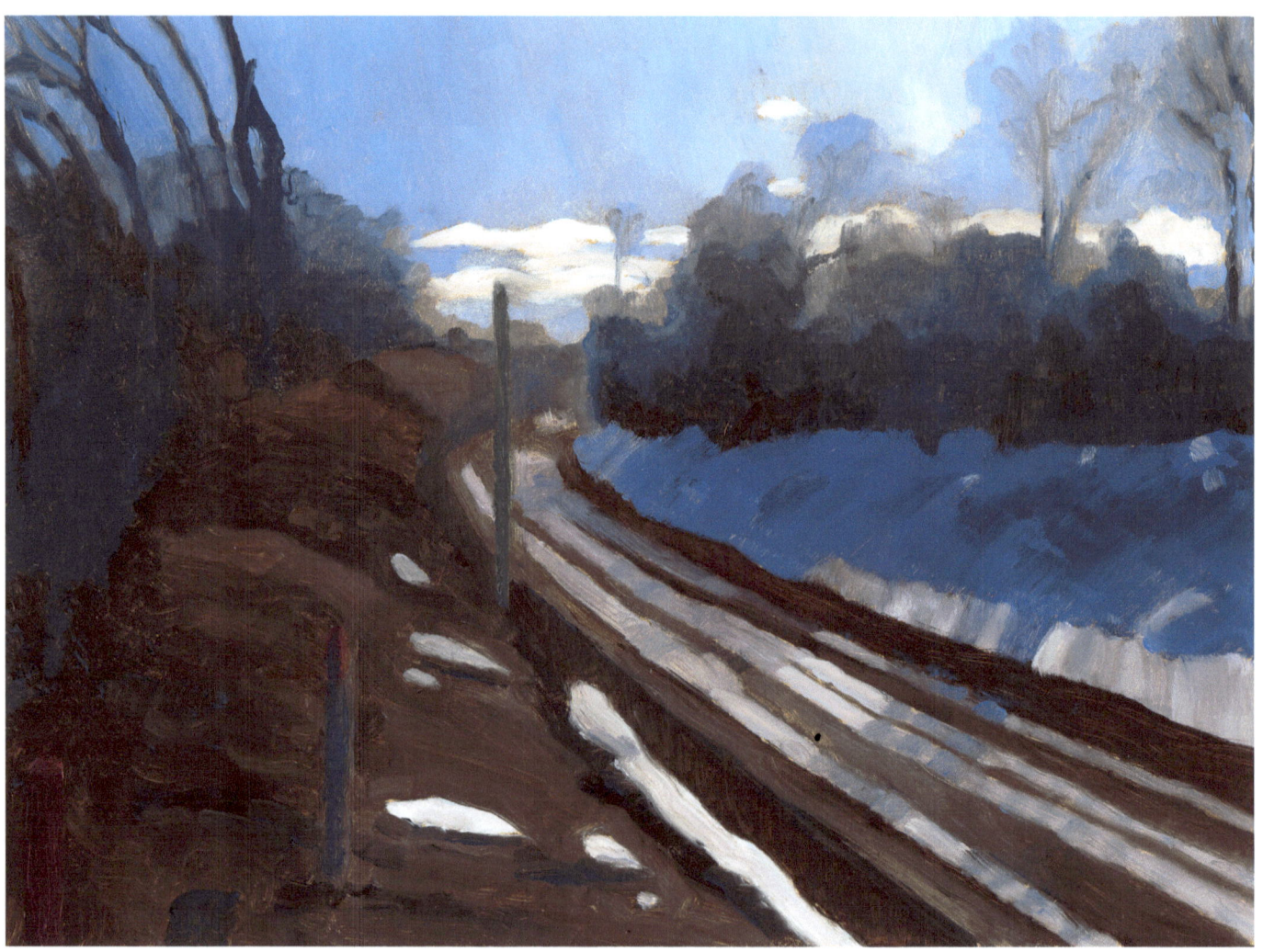

This view from the Narberth bridge whispers, "Let's go!"

Postcards from Merion

WEDDING DRESS AT THE CLEANERS

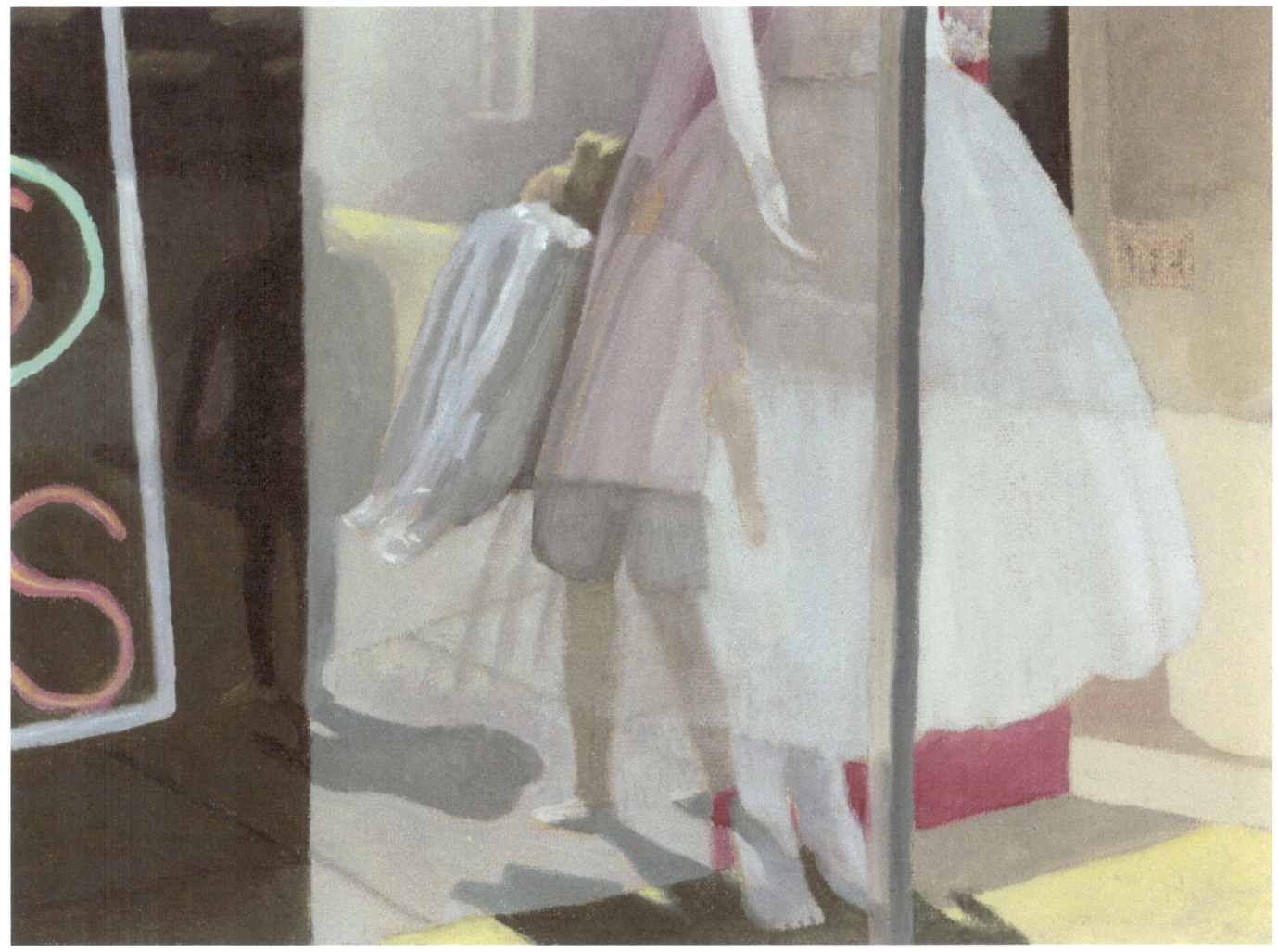

I think I have seen more wedding dresses in the windows of cleaning establishments in small towns than on brides. This one caught my eye as some departing customers were reflected in the window.
Narberth

Postcards from Merion

SMALL TOWN HOUSES

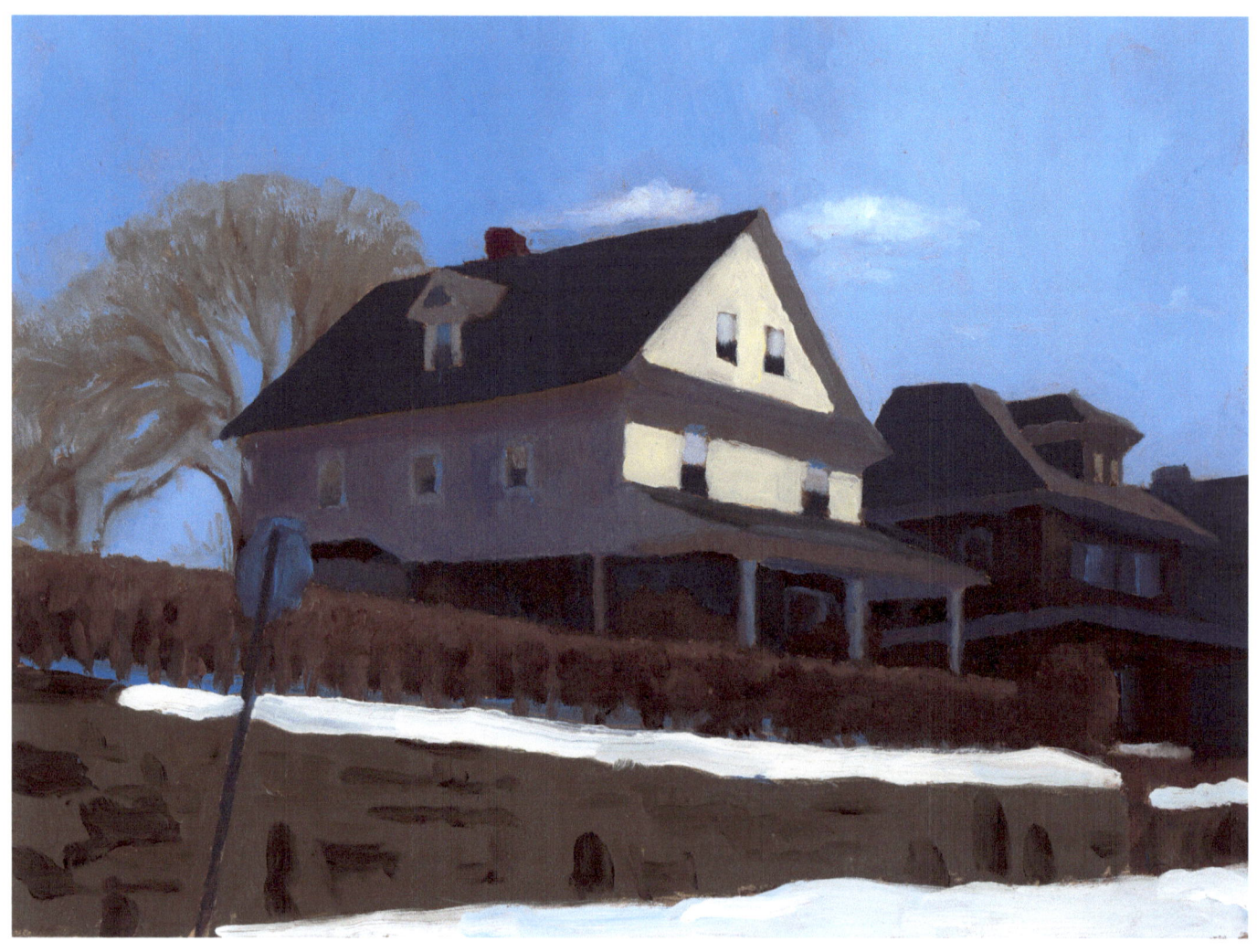

These lovely old houses are in Narberth, one of the nicest small towns in America.
Narberth

Postcards from Merion

AUTUMN IN NARBERTH

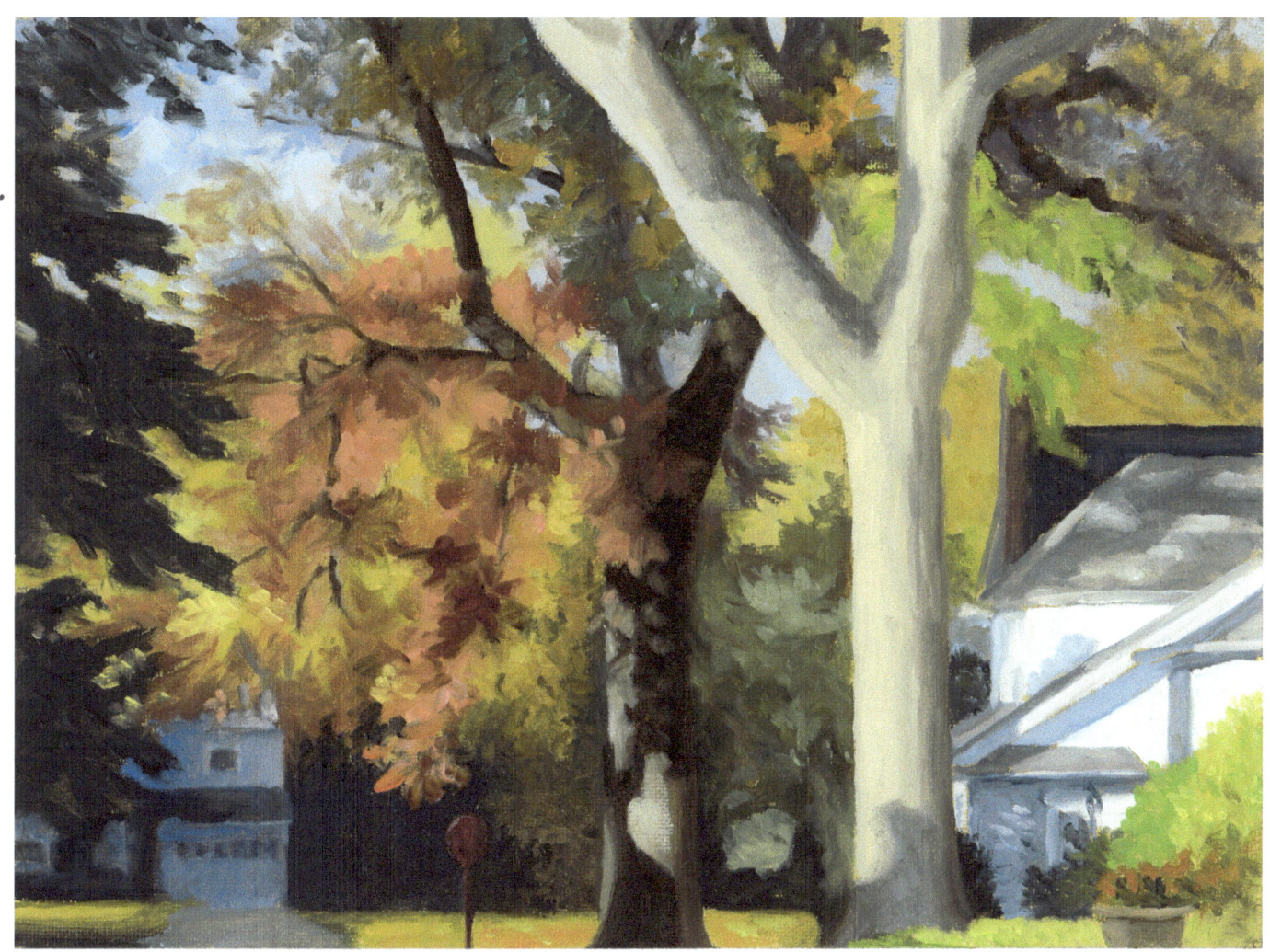

*Rockland Road just as it comes into Wynnewood Avenue,
with Merion on one side of the street and Narberth on the other.*

Postcards from Merion

DORM FIRE ESCAPE

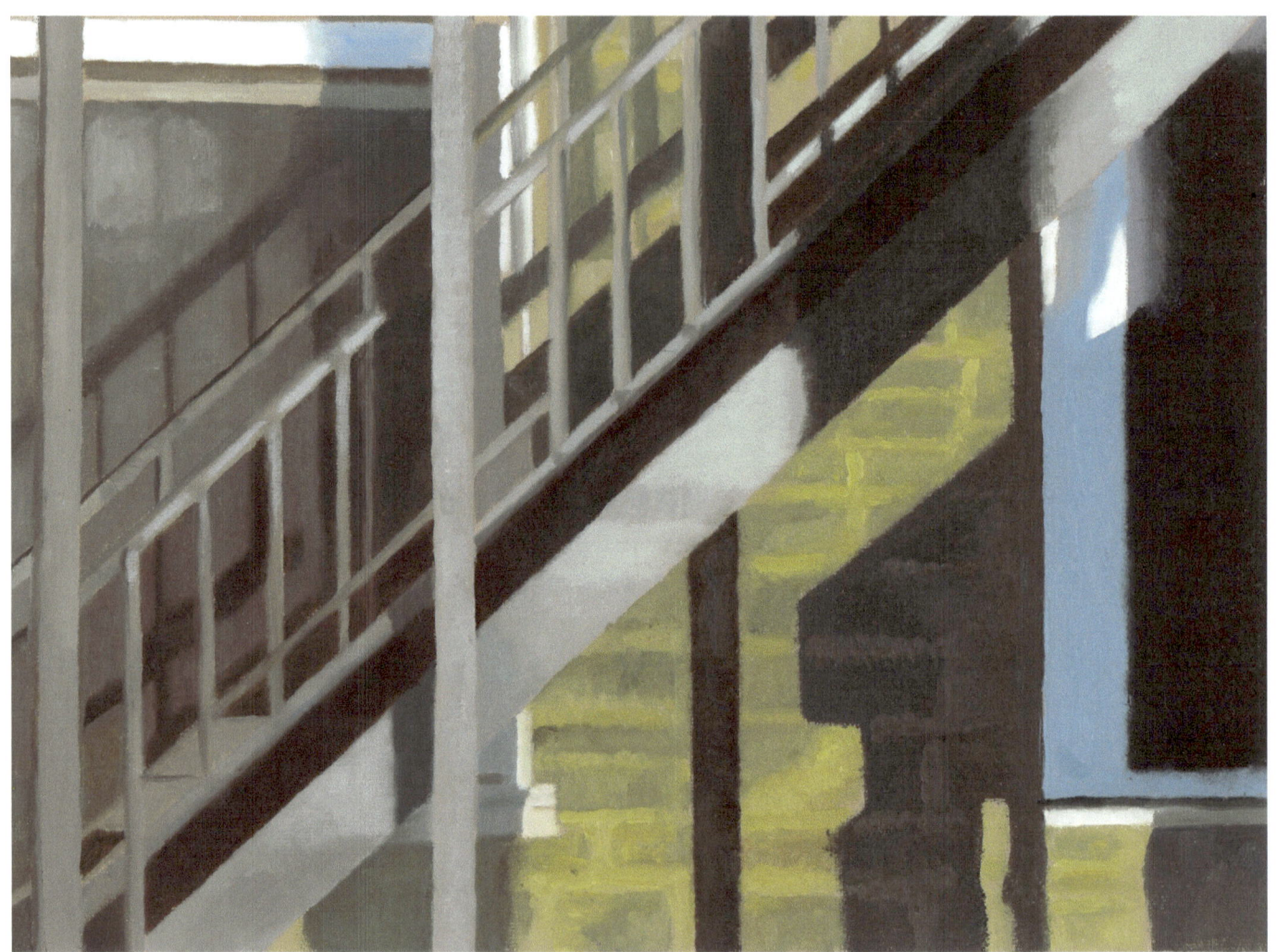

*The late afternoon sun creates a composition in gray and beige on this dorm fire escape at Saint Joseph's University.
Merion*

Postcards from Merion

JORDAN HOUSE

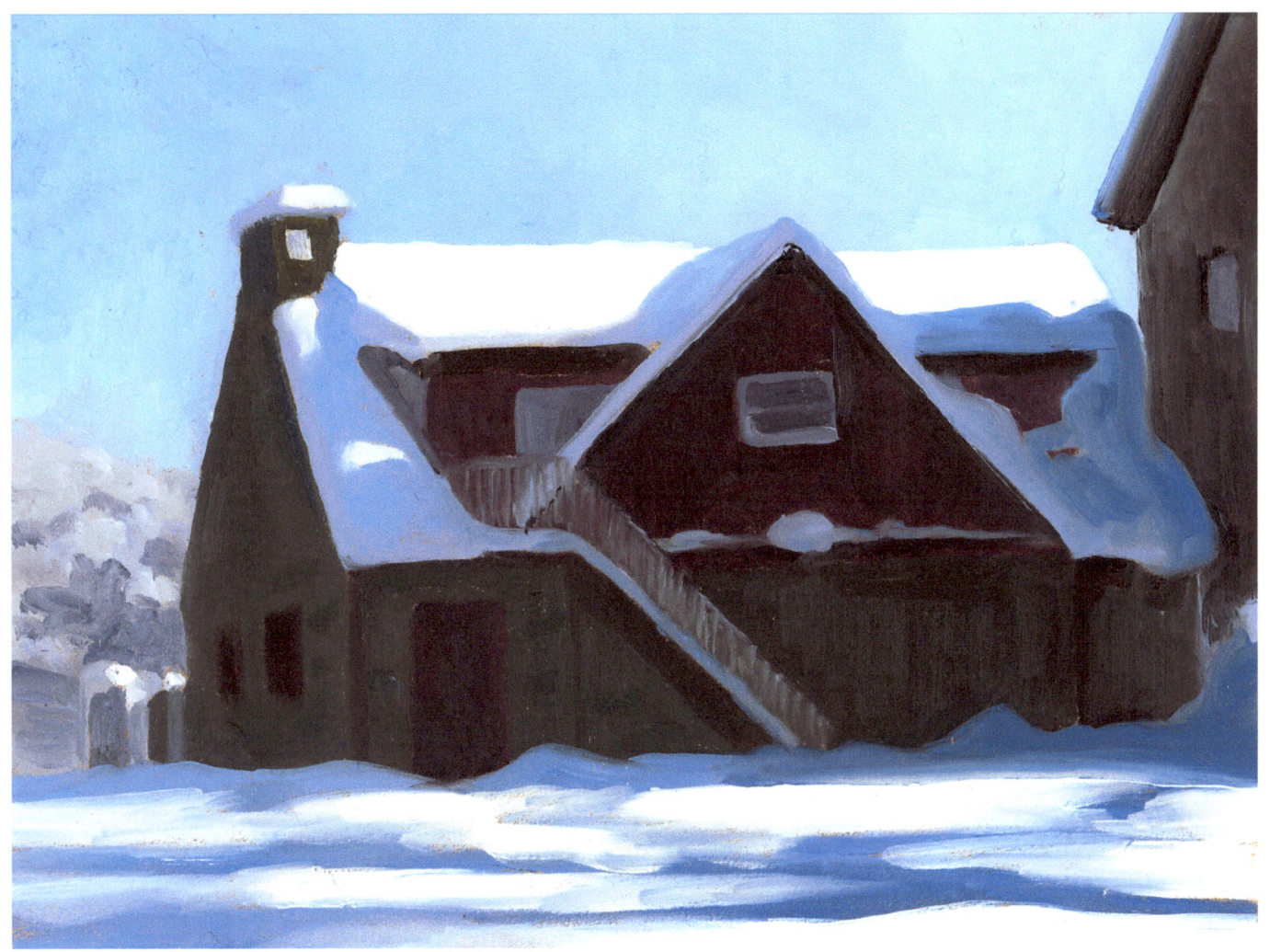

A residence at Saint Joseph's University
looks like it would be quite a snug place to be studying
on this chilly winter afternoon.
Merion

Postcards from Merion

BARNES FOUNDATION

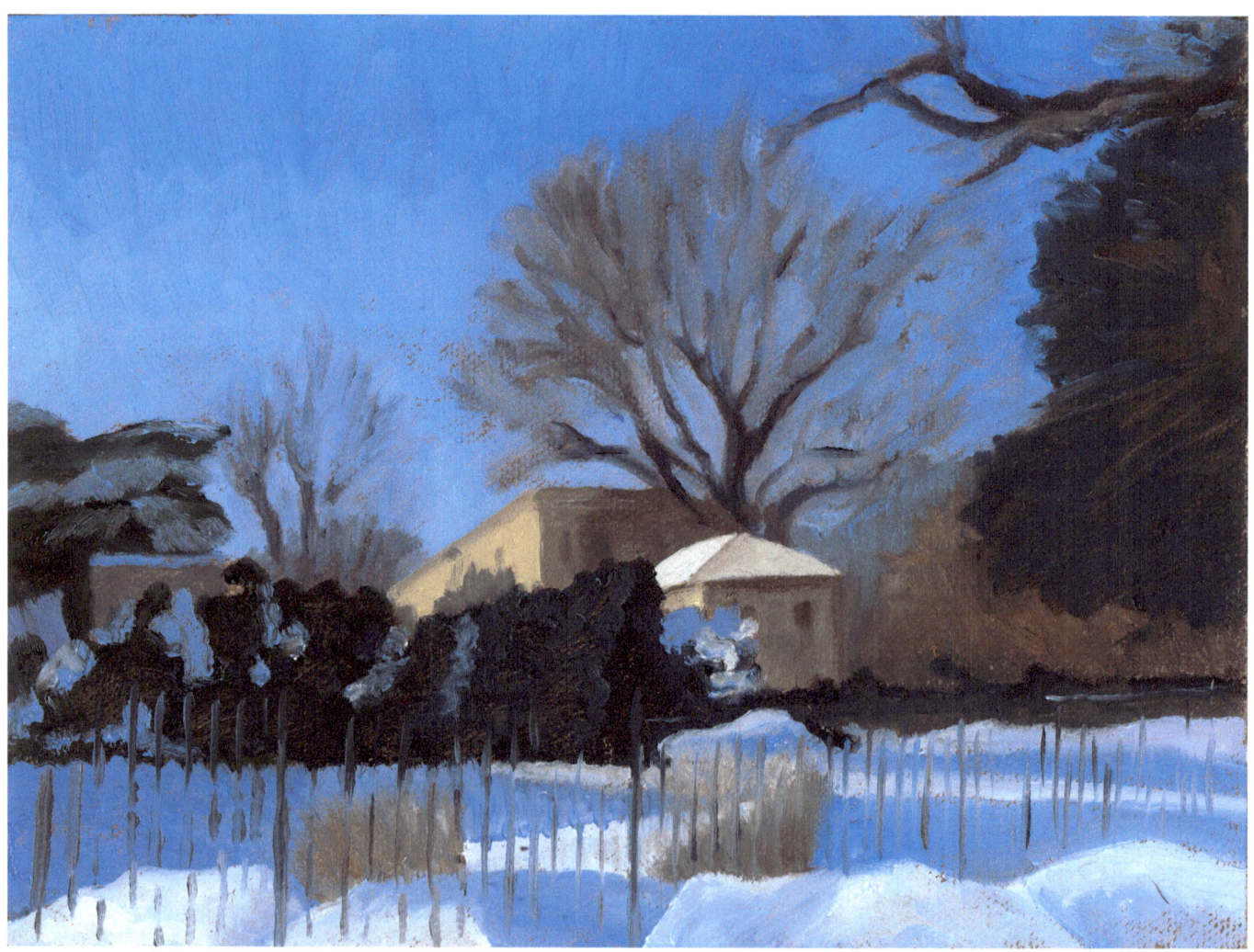

*The original home of the Barnes Foundation.
Merion*

Postcards from Merion

WELL AT THE BARNES FOUNDATION

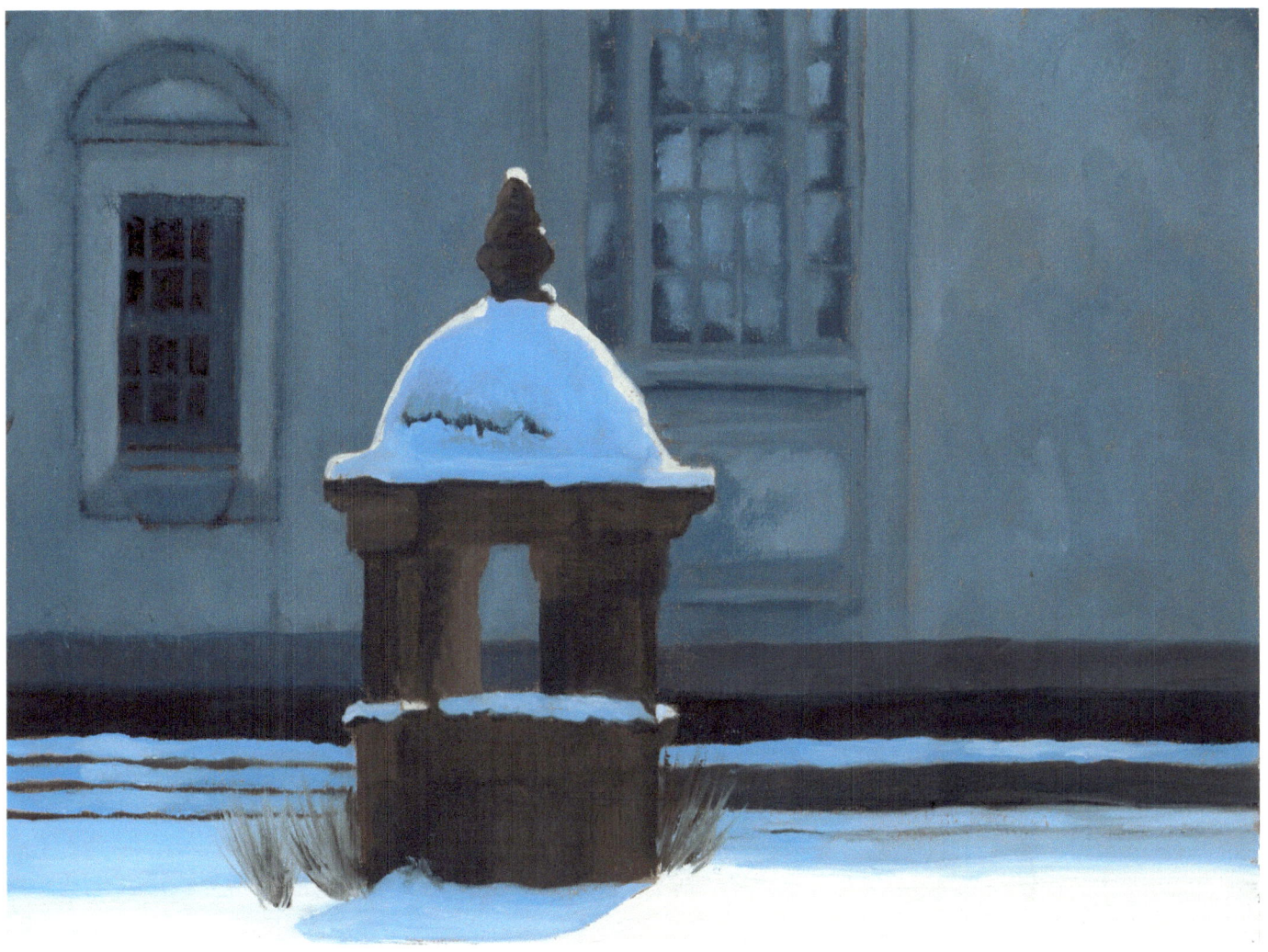

This well was purchased by Albert Barnes in Port-Manech,
a fishing village in Brittany, France and transplanted to the
original Barnes Foundation.
Merion

Postcards from Merion

LAPSLEY LANE AFTER FIRST SNOW

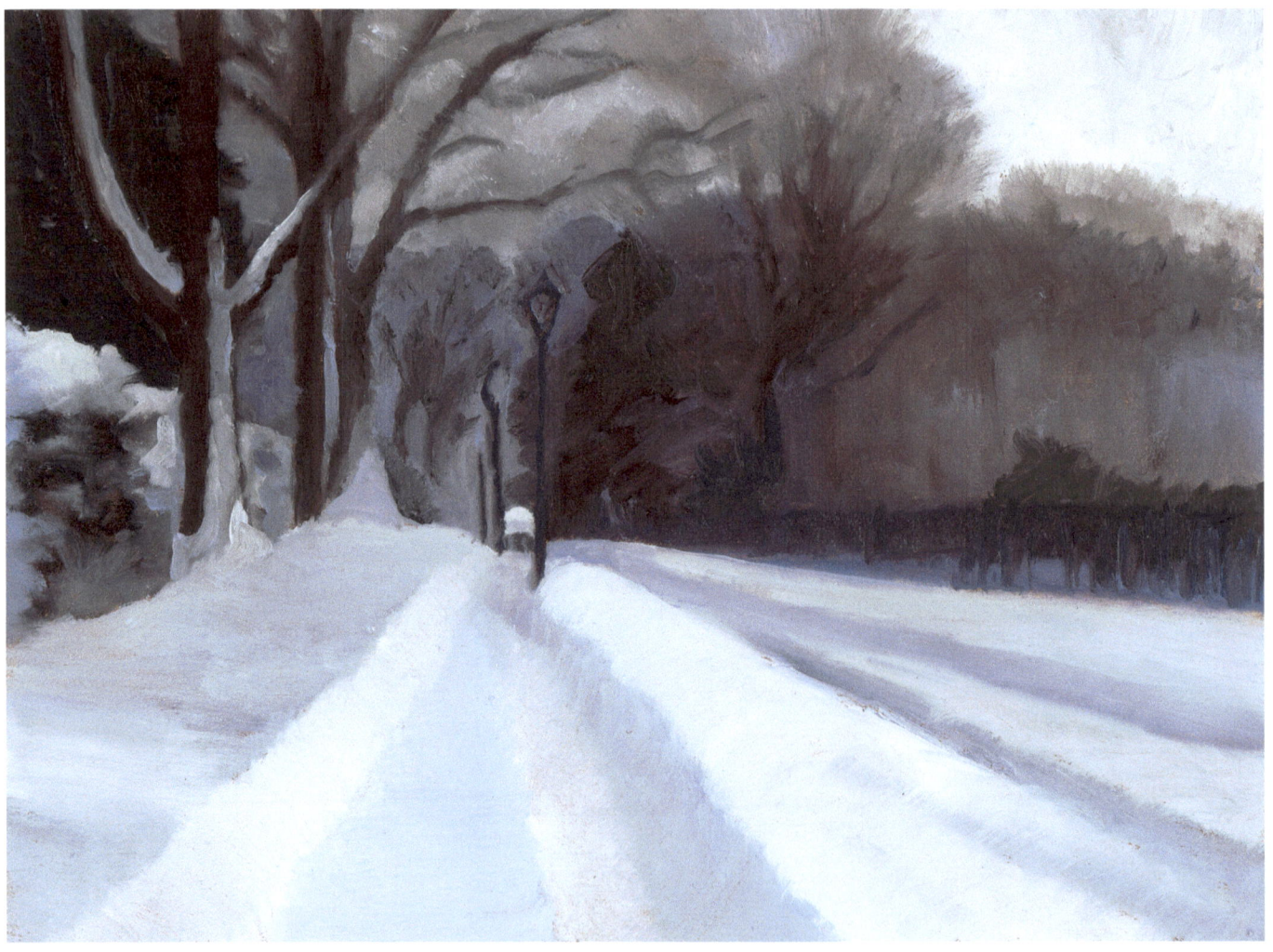

*The color of everything changes so much depending on the light.
Snow demonstrates these changes better than anything.
Merion*

Postcards from Merion

WINTER SUNSET

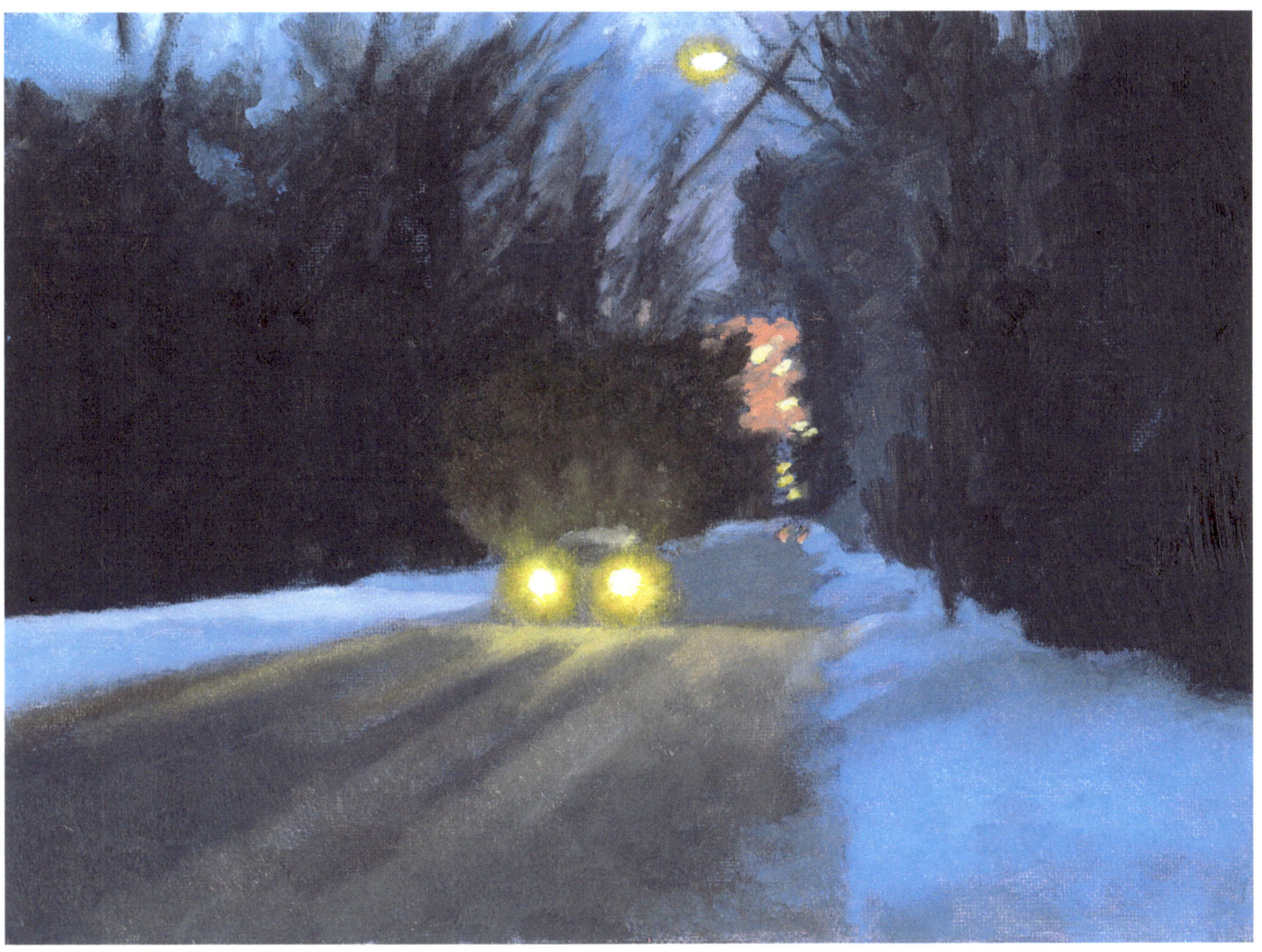

Every year around Christmas the sun sets at the very bottom of Latch's Lane.
Merion

Postcards from Merion

UNION AVENUE

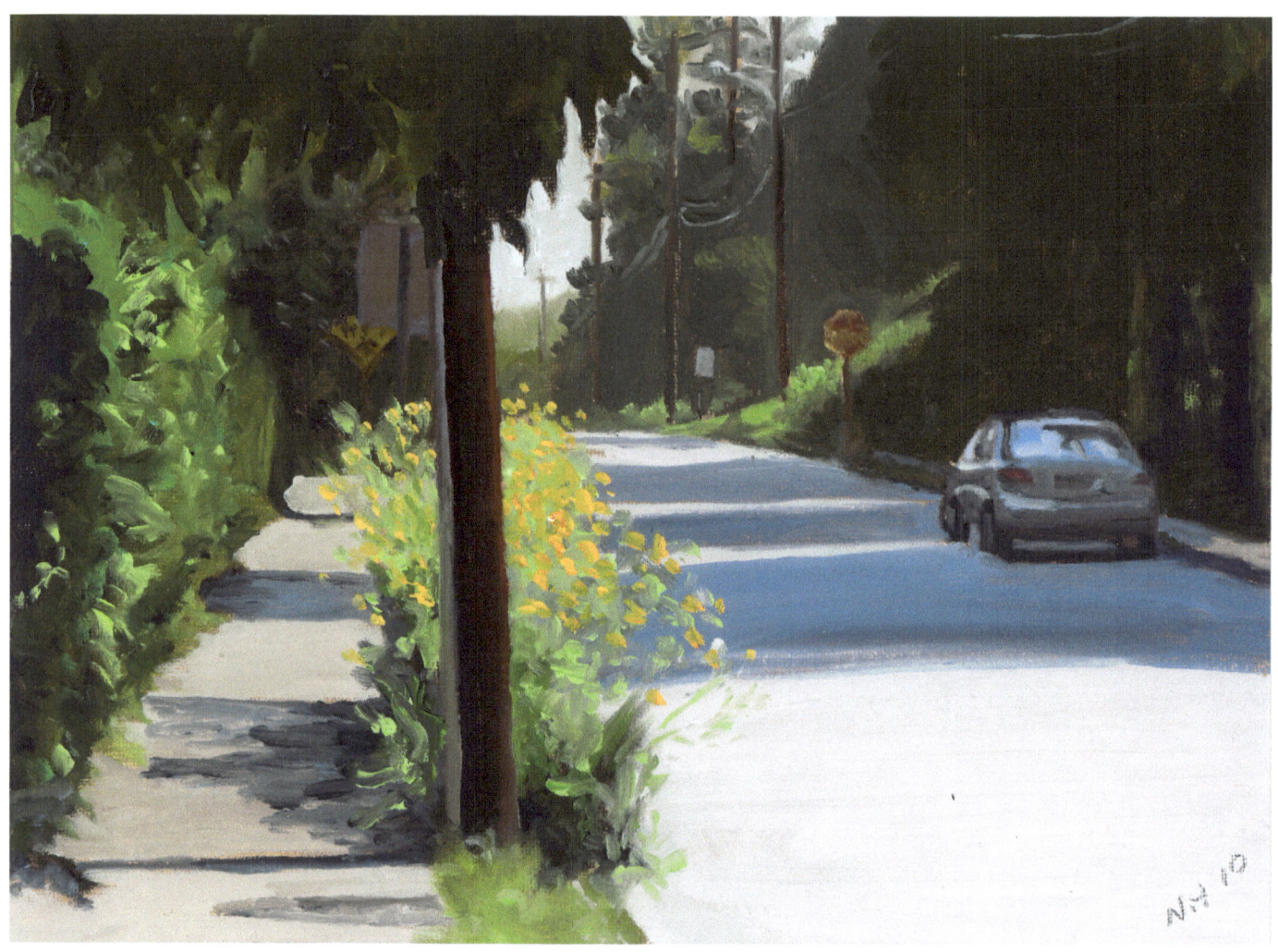

*Sprightly curbside flowers soften the streetscape
on Union Avenue in Bala Cynwyd.*

Postcards from Merion

CONNECTIONS

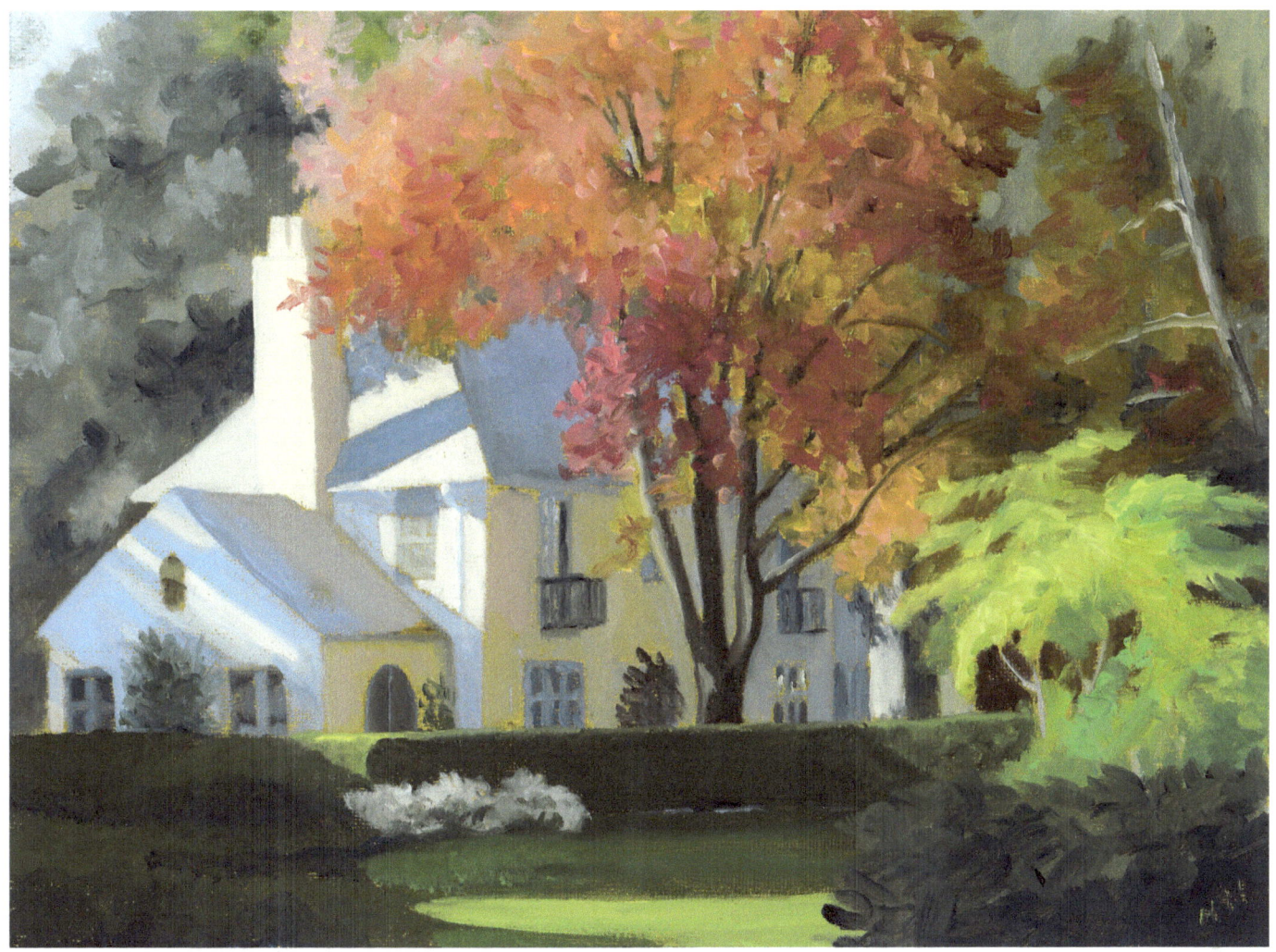

*This fine old house is many shades of white depending on
where the sun is, and which tree color is bouncing off its surface.
Merion*

Postcards from Merion

SHADOW PLAY

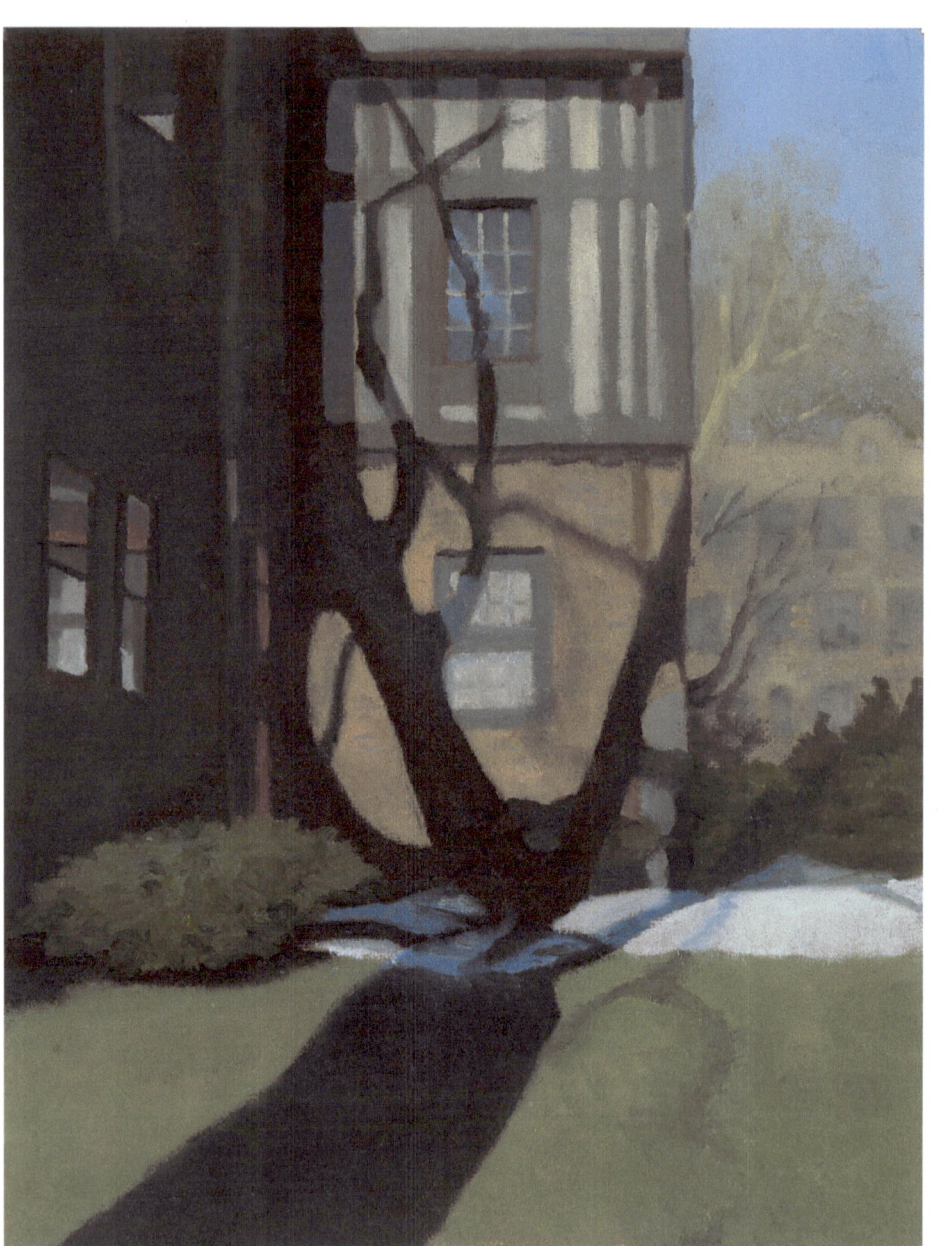

Shadows

Dance
Over the walls
Always moving
Not noticeably
But never stopping
Hugging all that pass
Receiving hugs back
Or rejected
They're dogs
Not getting too far
away
From their master
Pulling
And pulling
Taunting and teasing
Night falls
They fade away
Asleep.

Konrad Herman.

Merion

Postcards from Merion

MERION POST OFFICE IN THE RAIN

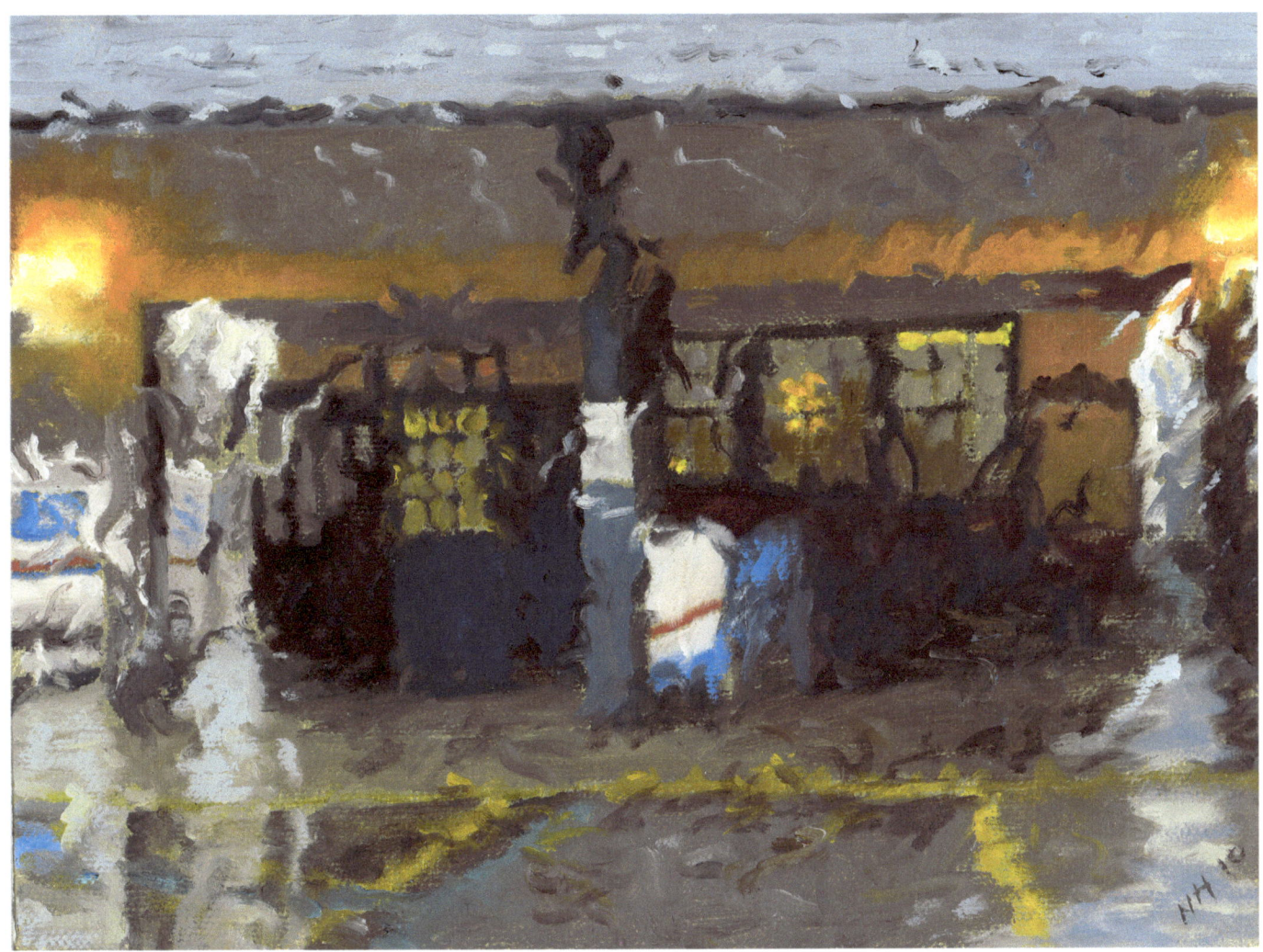

This was painted through the windshield on a soggy day.
Merion

Postcards from Merion

UNION AVENUE #2

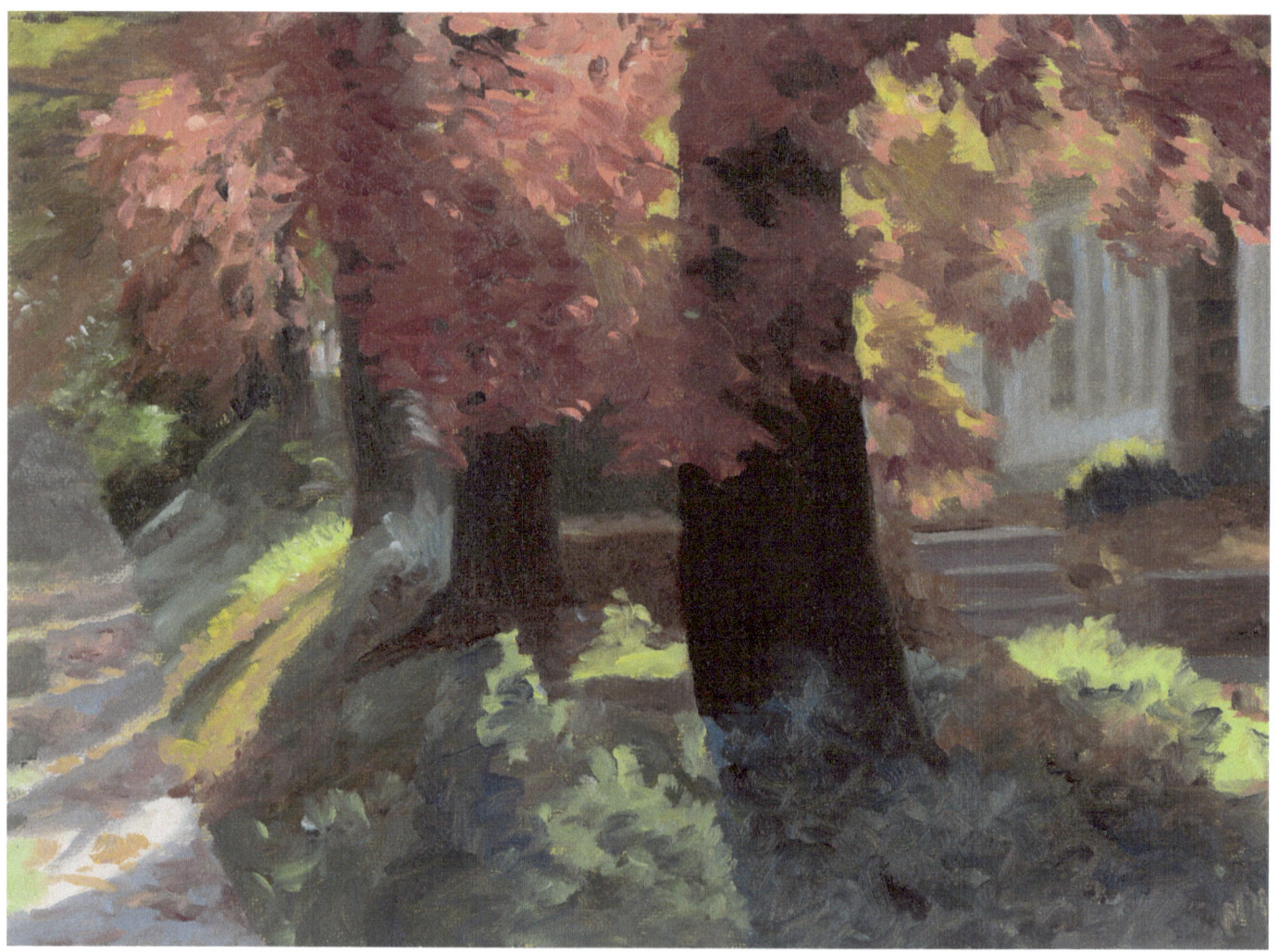

The Main Line has some of the best fall foliage in the country.
Bala Cynwyd

Postcards from Merion

EVAN JONES MILL

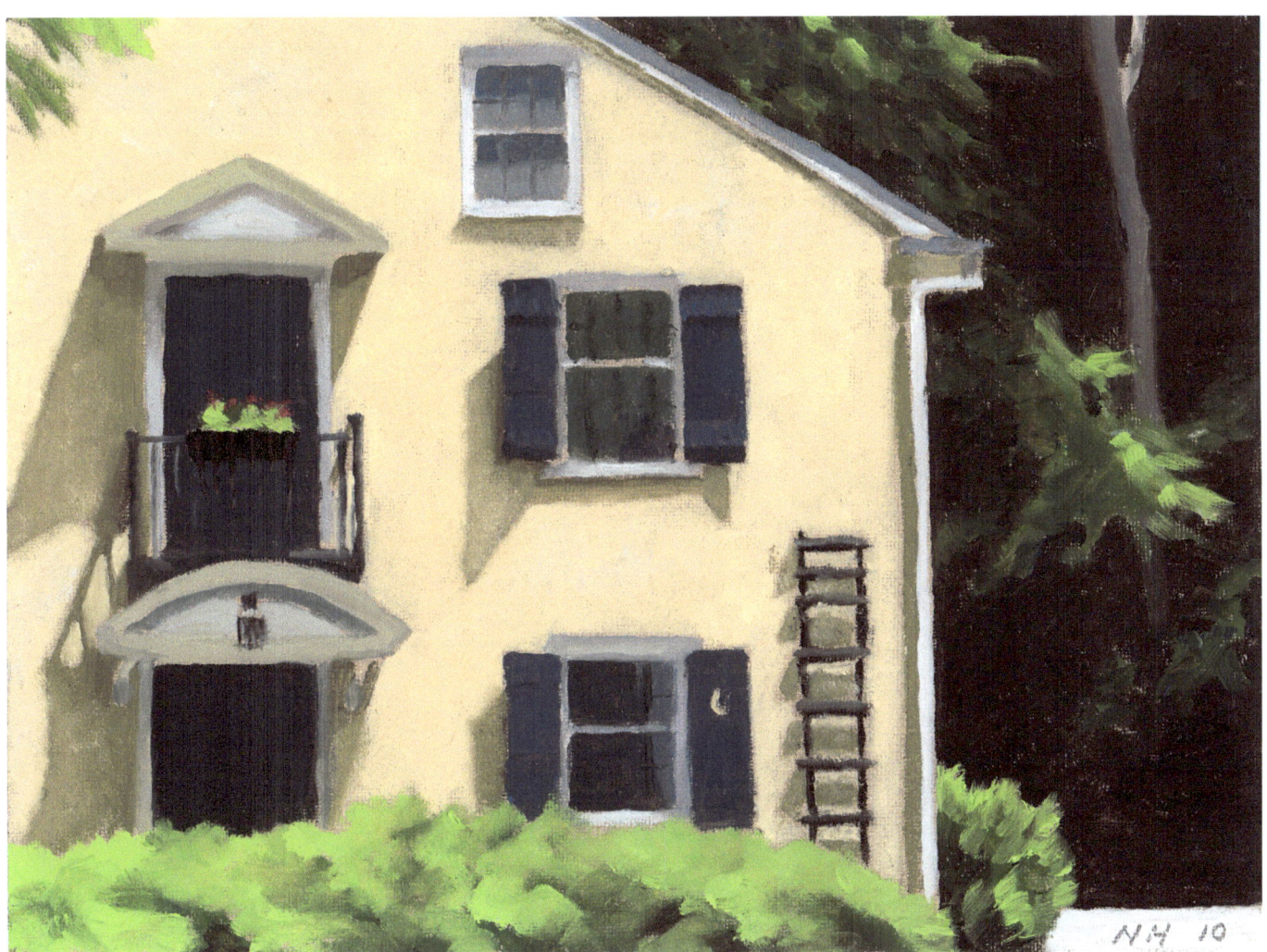

This very old mill building is on Mill Creek Road in Penn Valley.

Postcards from Merion

CHANTICLEER FOLLY

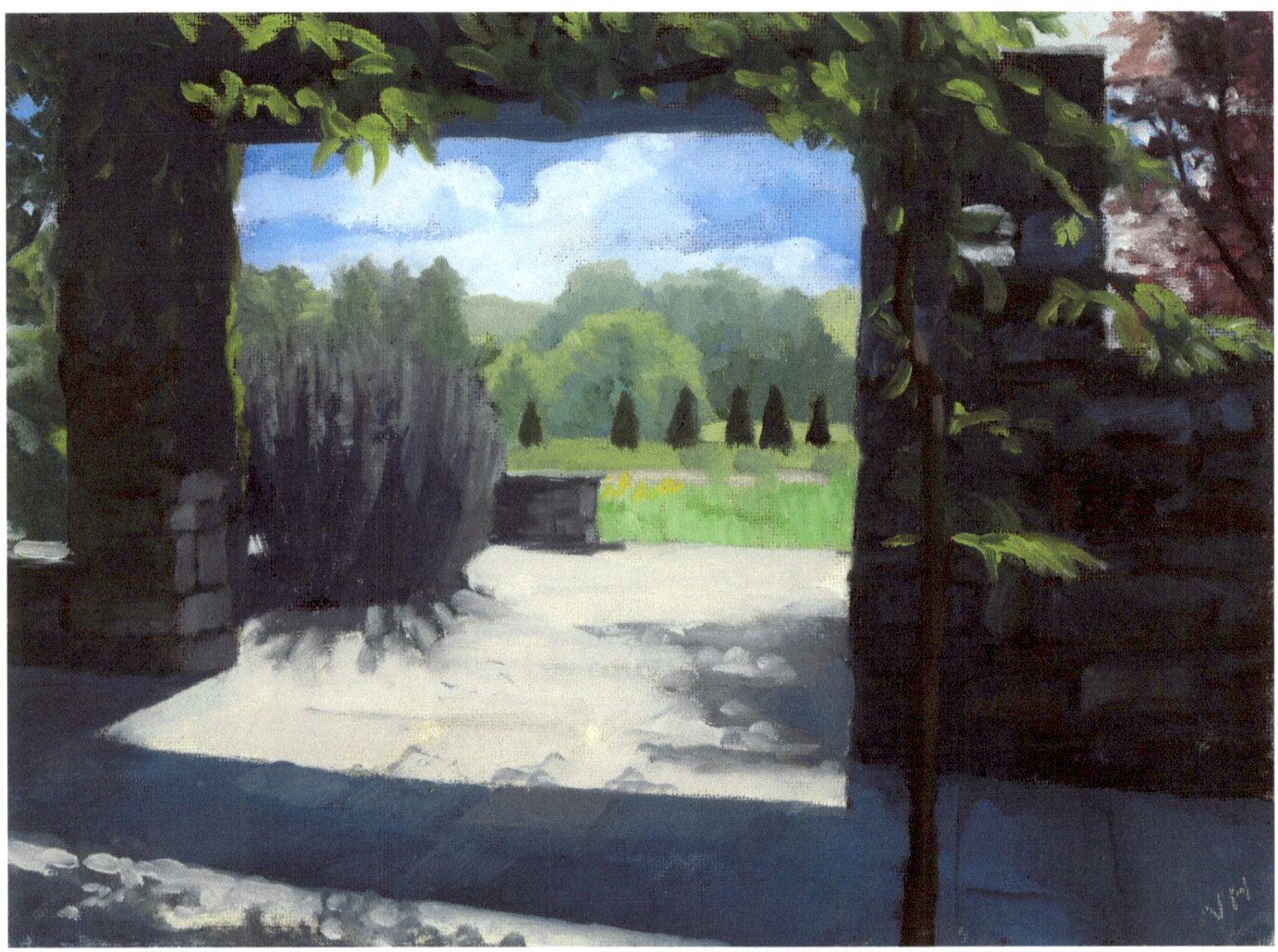

Peering through the "folly" there is the promise of a lovely afternoon strolling through the beautiful gardens at Chanticleer.
Wayne

Postcards from Merion

HARRITON HOUSE

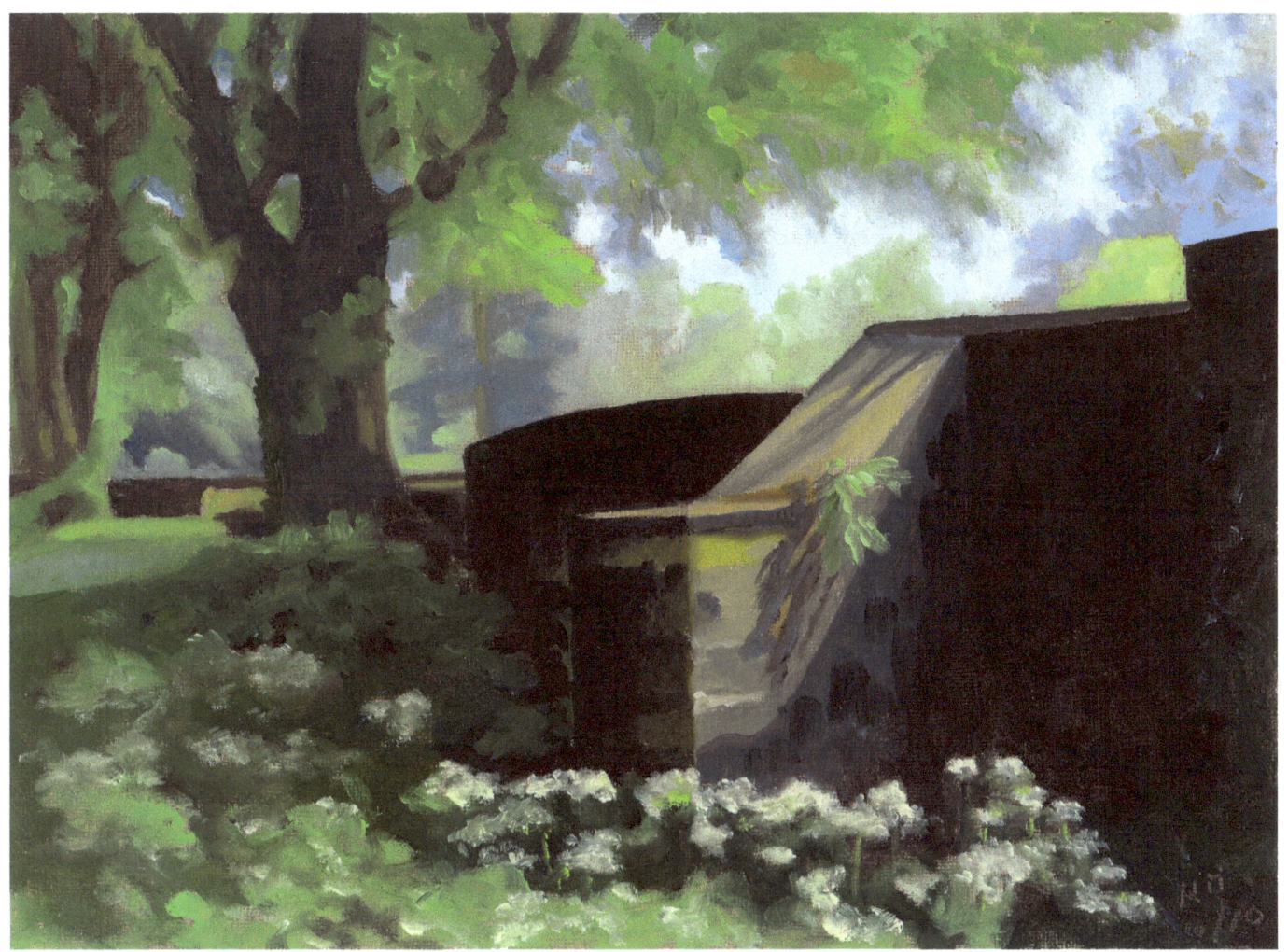

Built in 1704, the Harriton House was once the home of Charles Thomson who was the secretary of the Continental Congress.
Bryn Mawr

Postcards from Merion

APPLEFORD

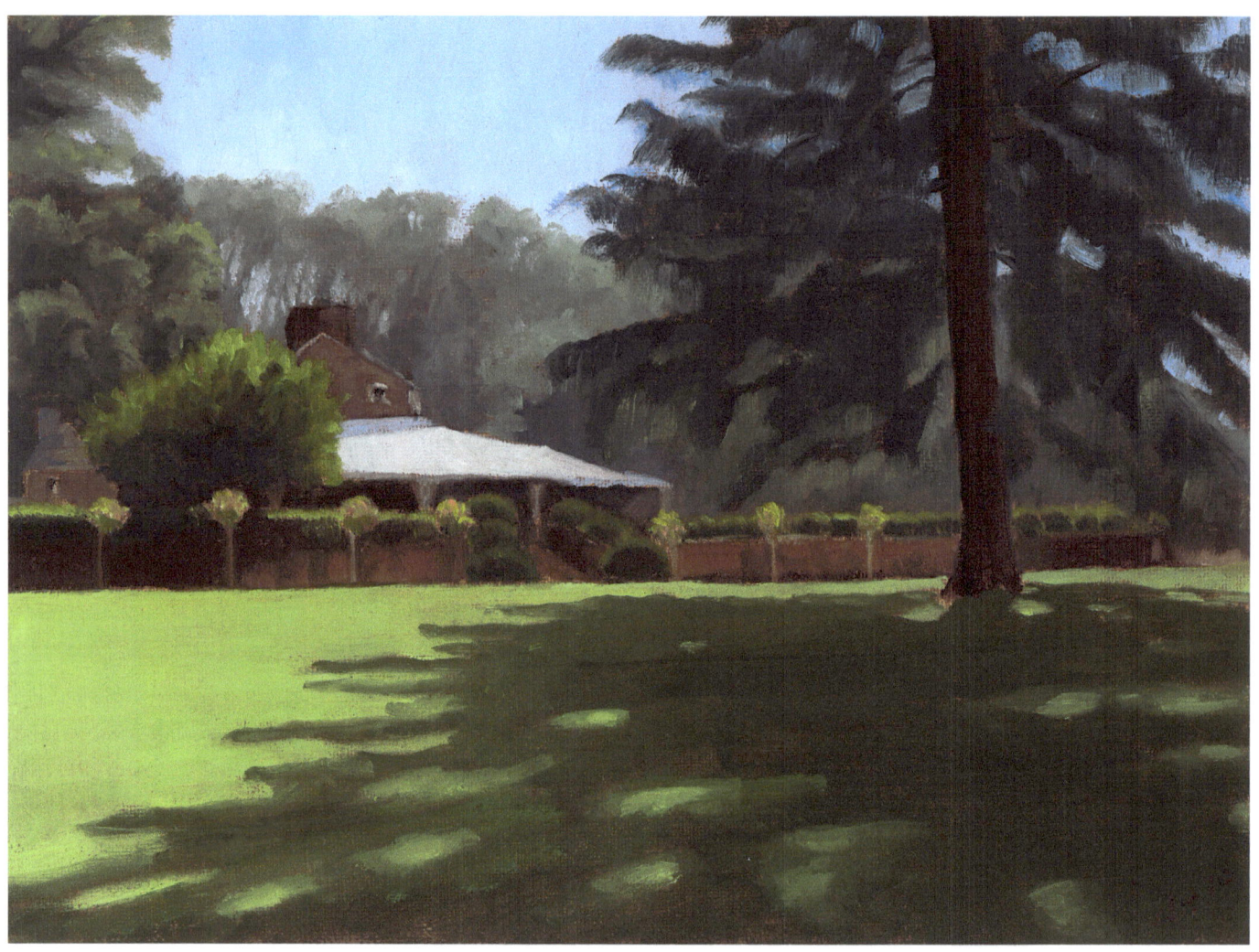

The estate of Appleford, 24 acres of arboretum and bird sanctuary, is over 300 years old.
Villanova

Postcards from Merion

SPRING

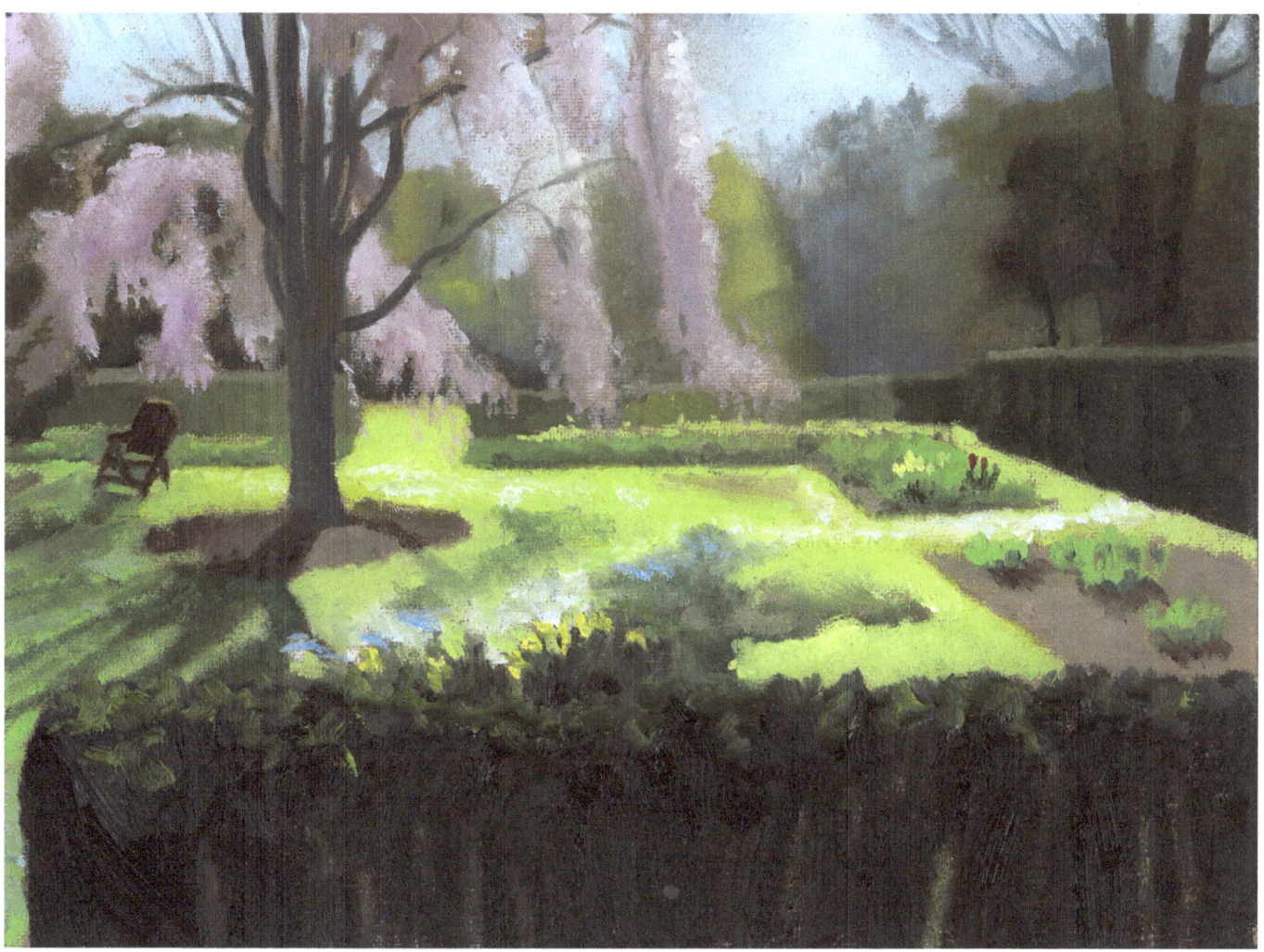

The joy of a garden in the spring is one of the things that make living in this part of the country so glorious. This is my weeping cherry tree around April 15, my mother's birthday.
Merion

www.ingramcontent.com/pod-product-compliance
Lightning Source LLC
Chambersburg PA
CBHW050358180526
45159CB00005B/2064